Beach House

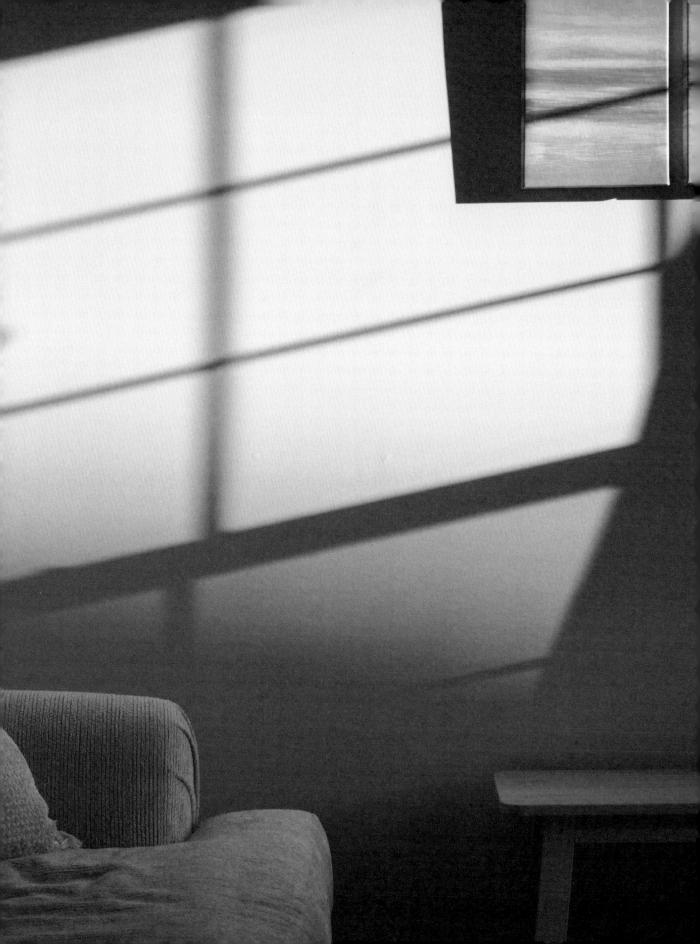

Beach House

Relaxed spaces inspired by the coast

Harper *by* Design

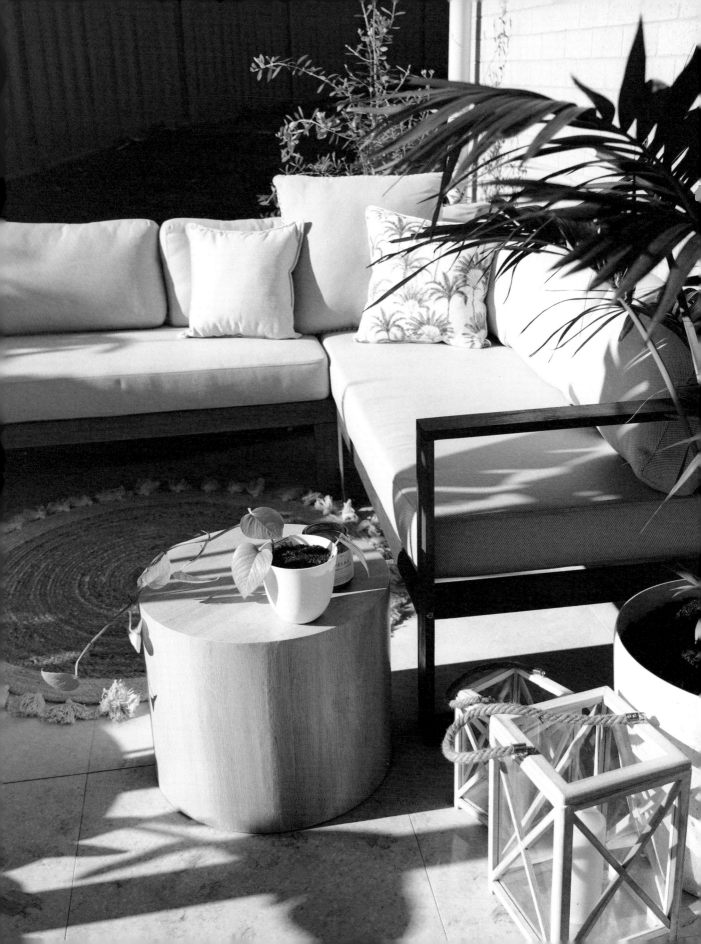

contents

the living room 8

the kitchen 50

the bedroom 90

the bathroom 130

the outdoors 168

intro

The sound of waves rhythmically hitting the shore, the taste of salt on your lips following a morning dip, the sweet relief of a gentle sea breeze taking the sting out of the afternoon sun – there's something intoxicating about being by the beach. No wonder so many of us want to capture this carefree vibe in our homes.

Beach house living distils the inimitable essence of the coast, transforming it into an experience we can enjoy every day. From the living room to the kitchen, bedroom and beyond, every room of a beach house plays an important role in building the story of your home.

Whether you choose to embrace the barefoot beach-shack vibe with woven seagrass hangings and rattan furniture, or lean into the windswept cottage-by-the-coast theme with reclaimed nautical-style fixtures and dark-hued furnishings, your home should be a unique expression of your location, individuality and heritage.

If you live by the sea, or want to bring the coastal aesthetic to your inland abode, dive in and start experimenting with your home's interior design to bring your beach house dream to life.

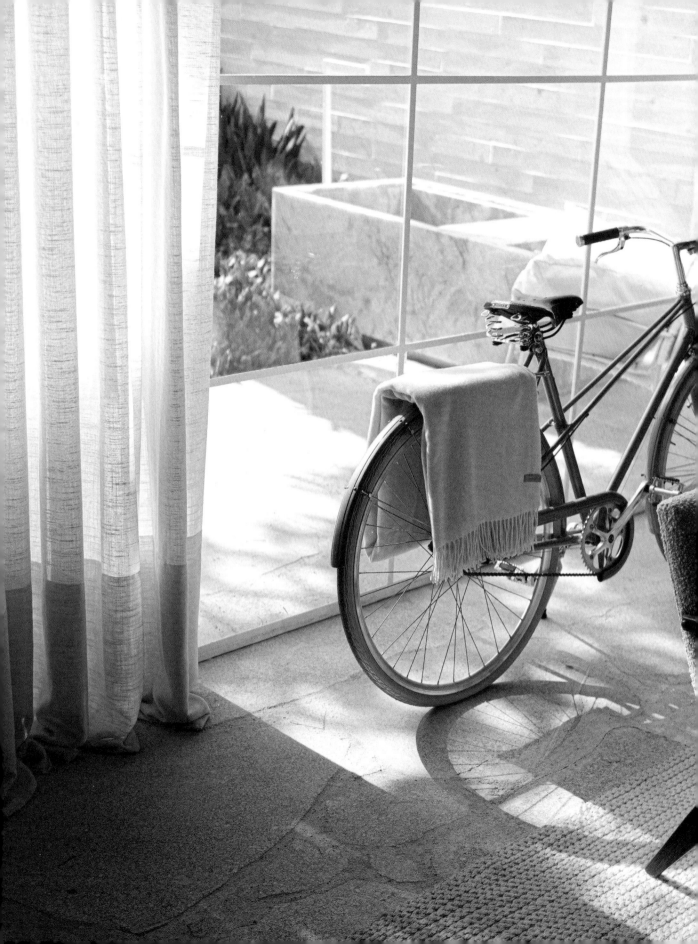

the living room

A space where we gather to relax, entertain and unwind, the living room is where we find comfort and connection. At its best, the beach house living room invites us to retreat from the world for a precious moment to enjoy the simple pleasures of an afternoon reading session, pre-dinner tipple with guests or late-night game of backgammon with friends. At the heart of the beach house living room sits a soothing space free from clutter, chaos and complexity, and full of breezy simplicity. After you get the fundamentals, use your creativity to make the space your own with unique décor, artworks, plants, objects and lighting that conjure up the wild spirit of the coast.

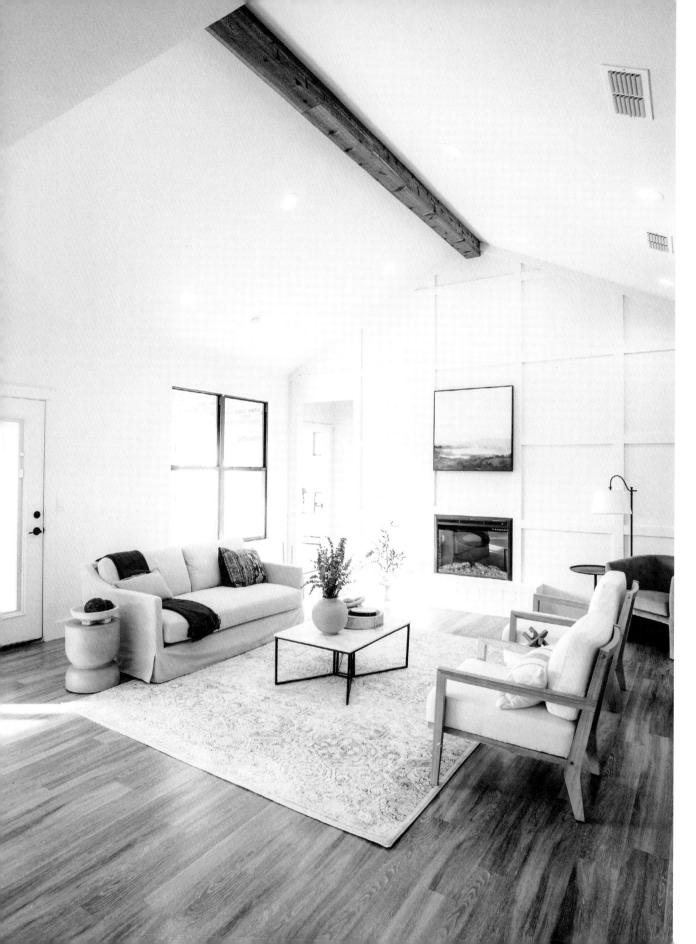

Bright lighting, high ceilings, clean lines and light timber finishes combine to create a sense of spaciousness and freedom.

A couch bathed in dappled afternoon light beckons to be napped on.

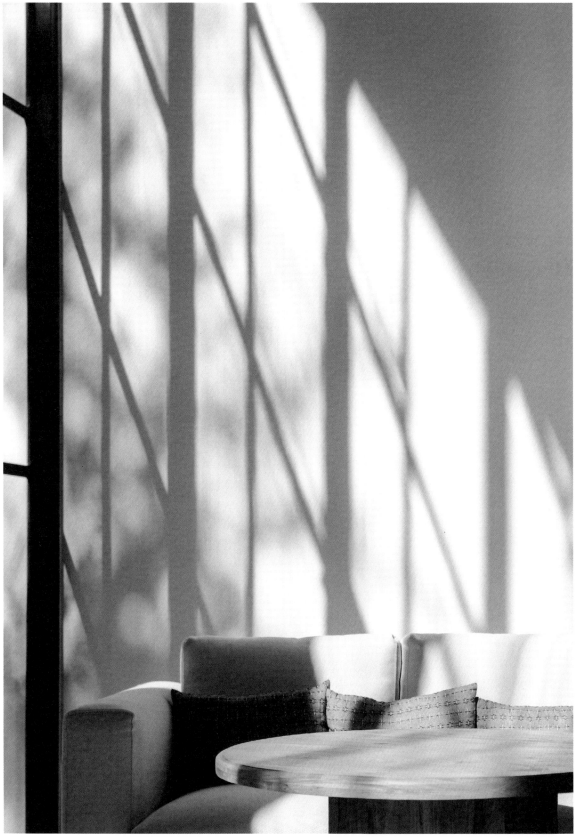

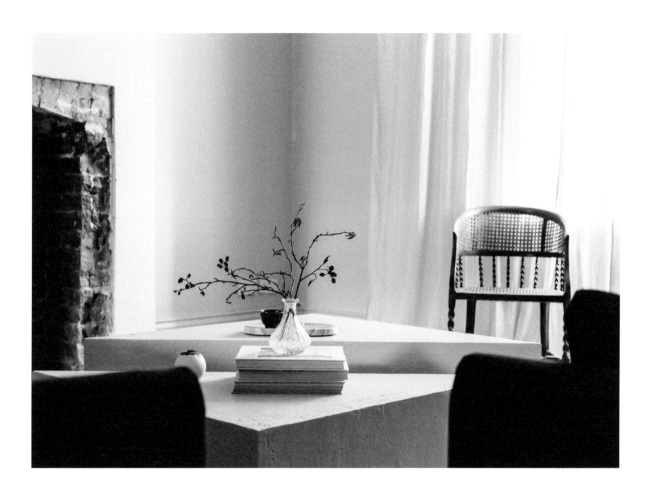

When drawn, sheer curtains create a soft lighting effect,
adding a touch of mystery and romance to the space.

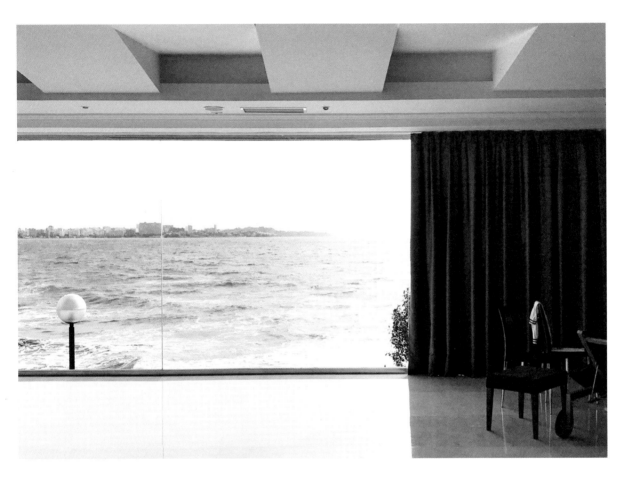

With the curtains open, natural light streams into the room, brightening and uplifting the space while allowing glimpses of the heavenly sea view.

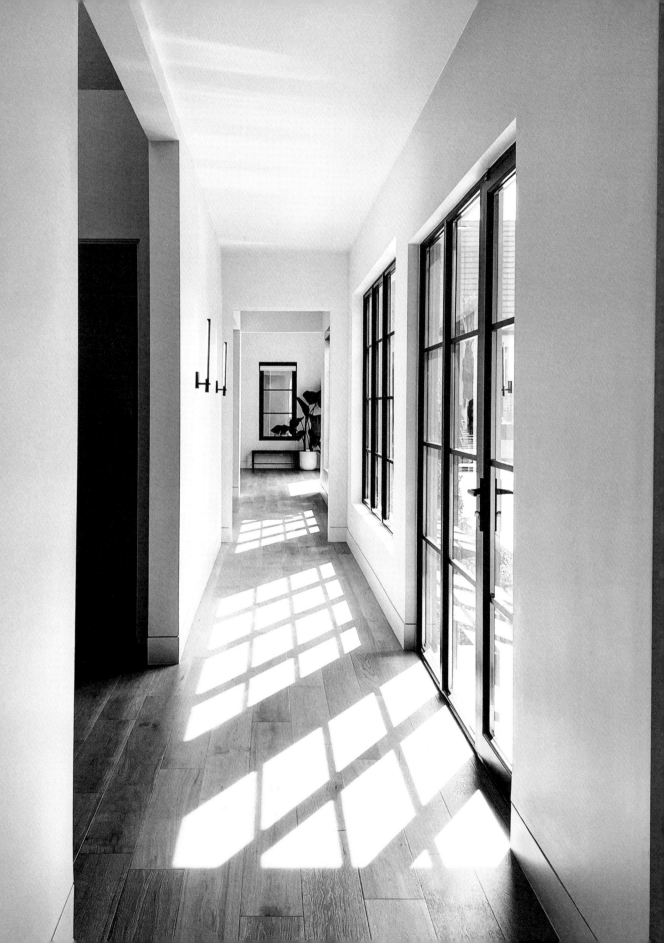

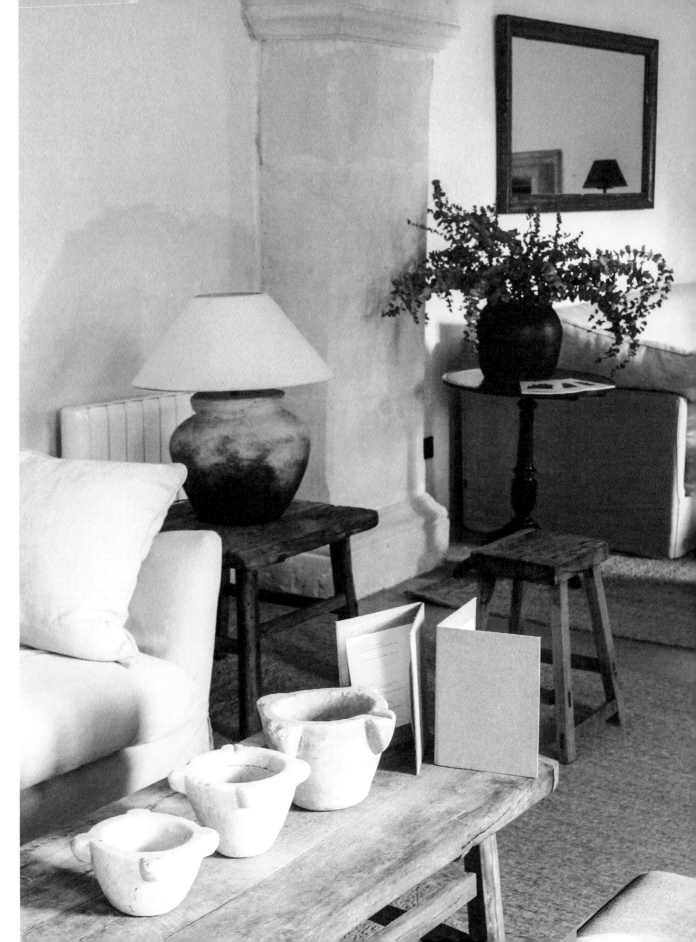

As the heart of the home, your living room should feel lived in (and loved).

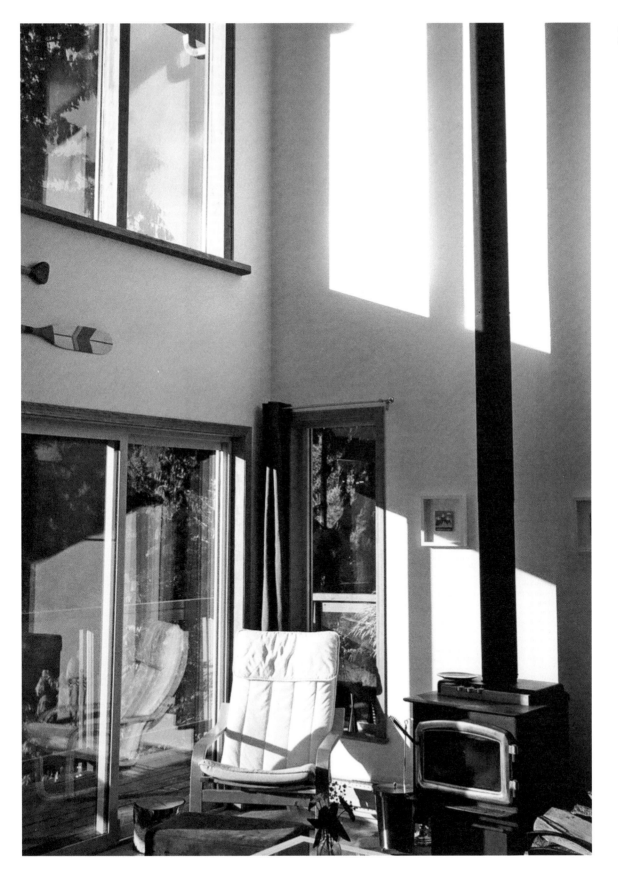

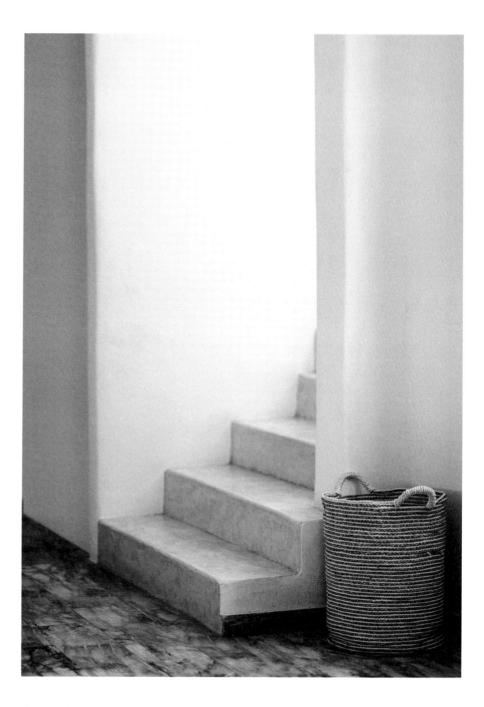

Curved archways and rounded corners bring softness to a room and throw shadowy shapes when bathed in natural light.

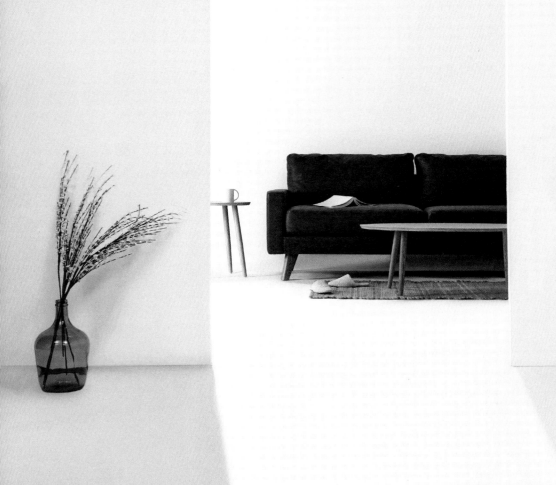

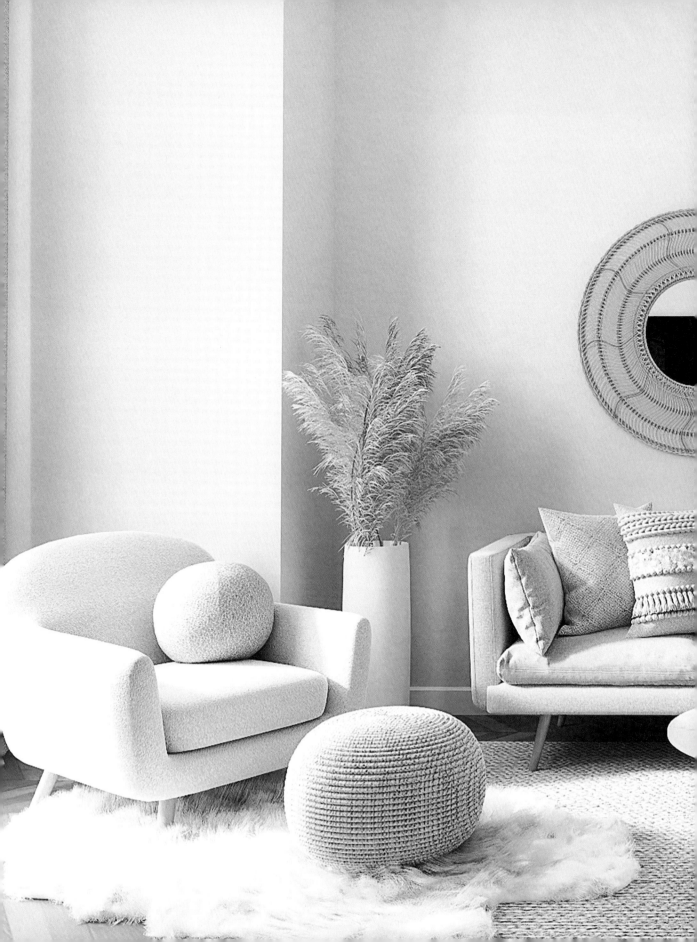

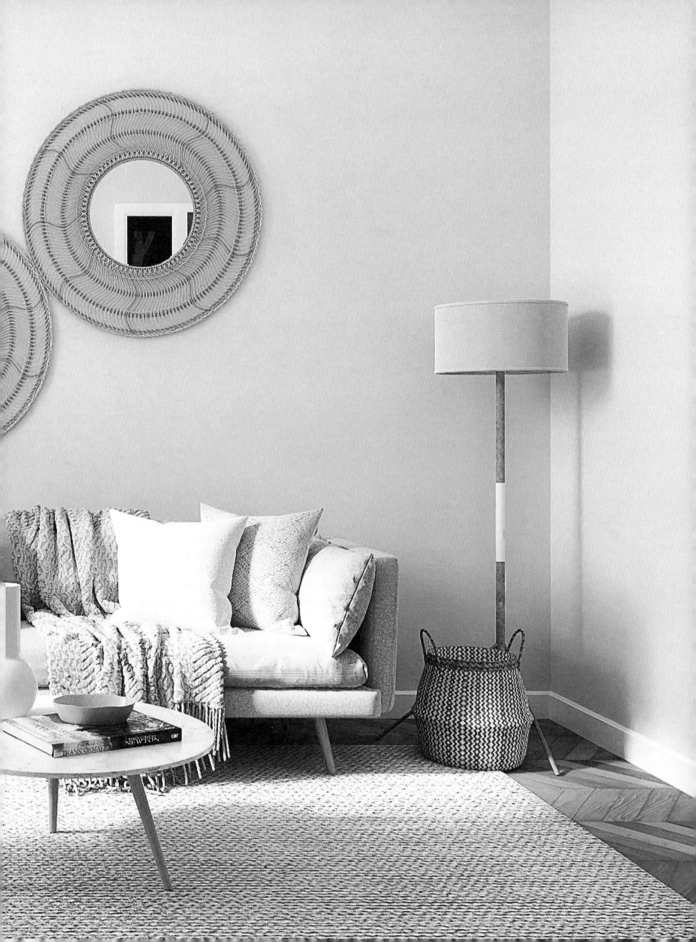

White painted walls and a matte, whitewashed ceiling with exposed beams open up this room, infusing it with rustic, nautical charm.

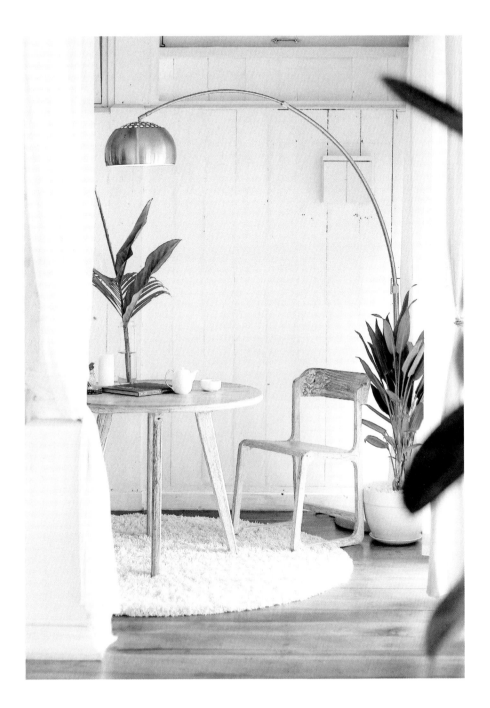

Painting timber surfaces white is a simple way to add a touch of coastal cool to a living room. The white rug, table, chair and planter build on the theme.

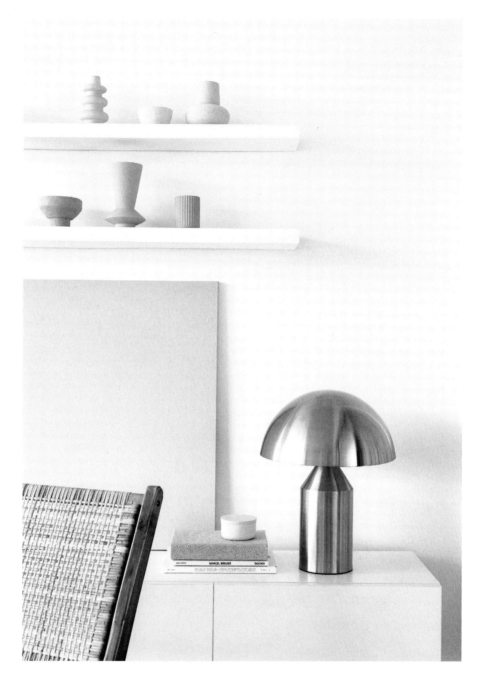

A single piece of gold-toned décor can add a splash of sunshine and warmth to your living space.

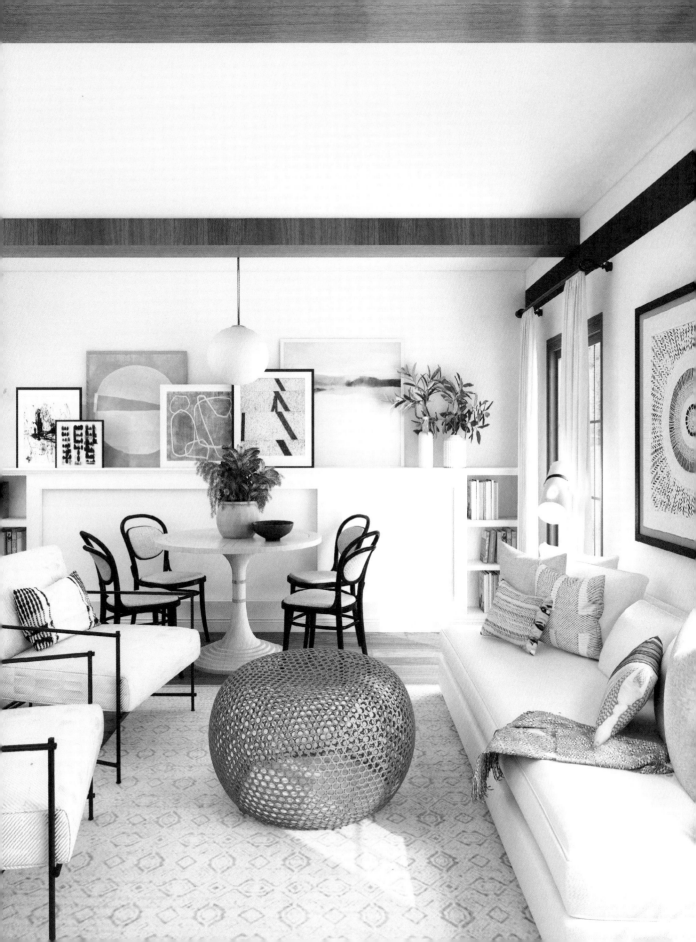

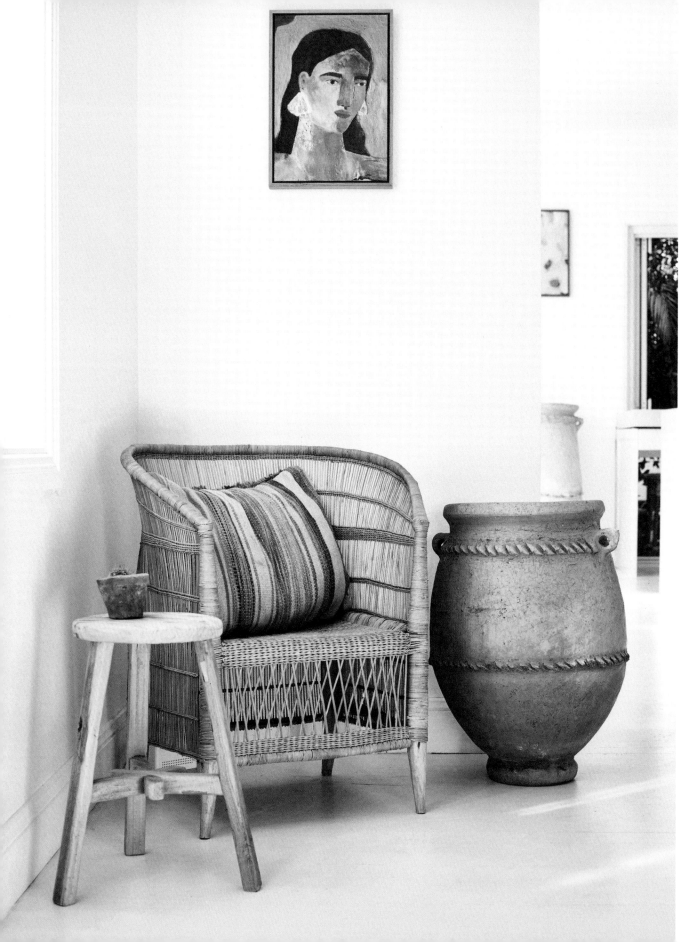

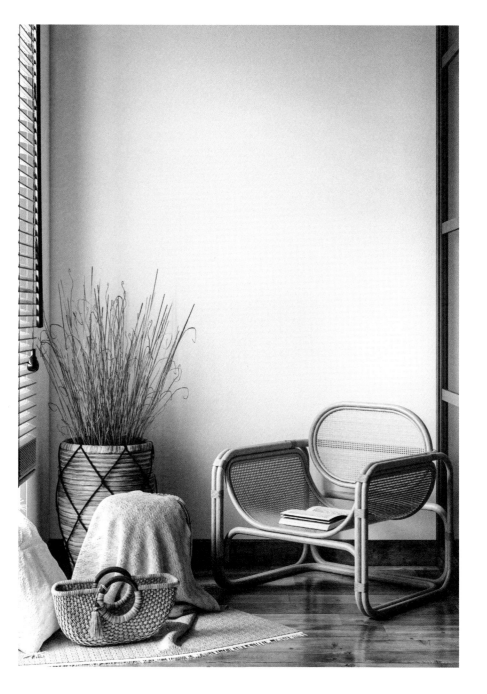

Fixtures and furniture made from woven natural materials are reminiscent of fishing nets and baskets.

A carefully curated cluster of beautiful objects displayed on shelves is a timeless beach house feature, which you can adjust as your style and collection evolves.

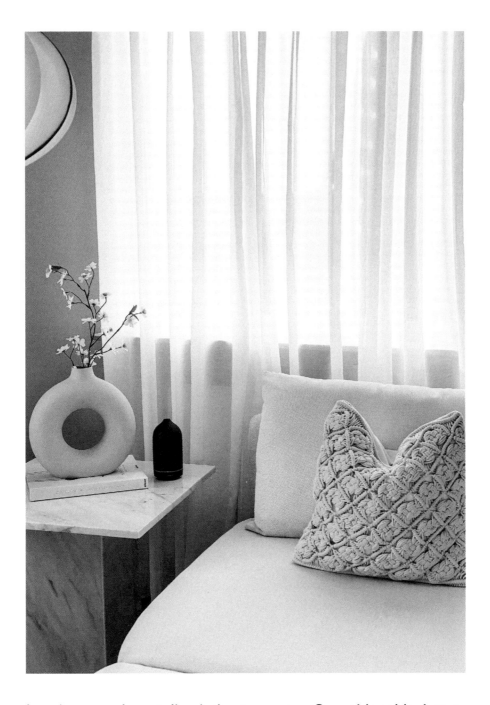

Less is more when styling intimate spaces. On a side table, just a few simple items can have a big impact. Change the items to suit the season or your mood.

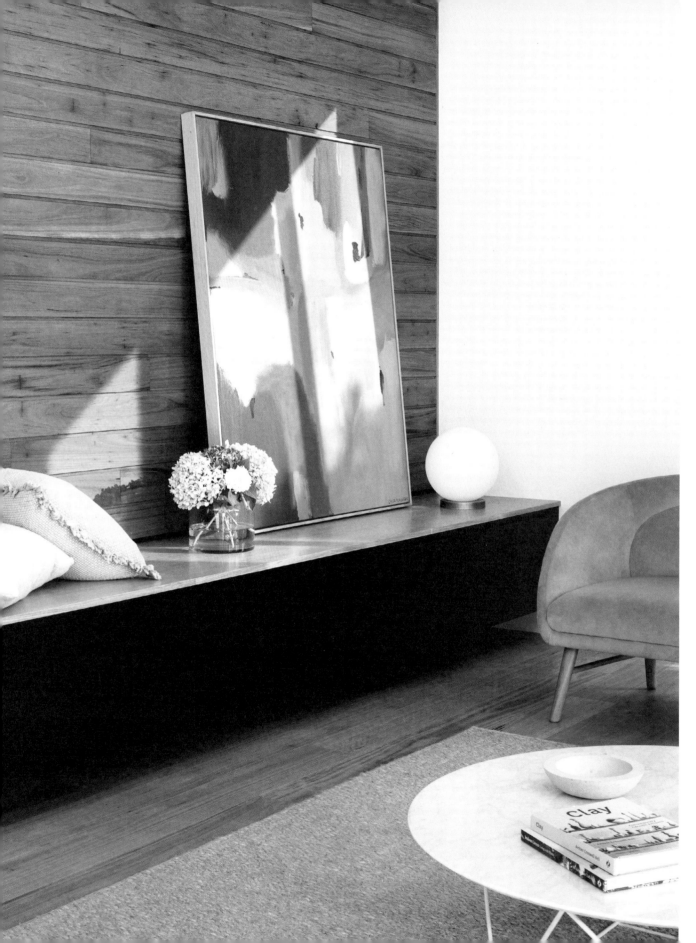

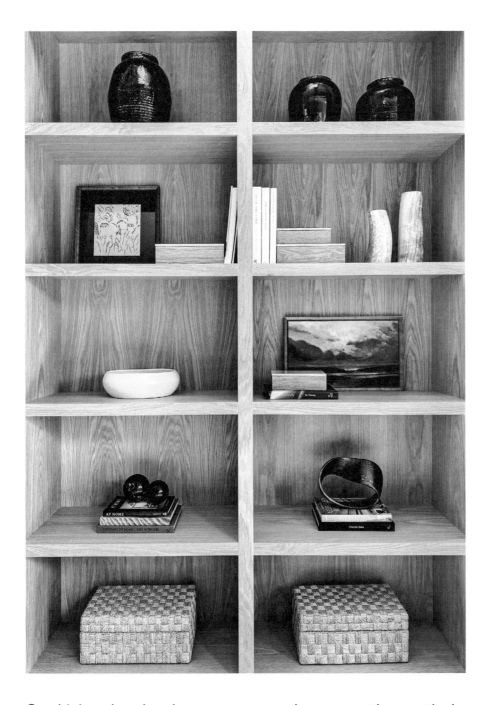

Combining closed and open storage options merge the practical with the beautiful. Stow bulky items away while displaying your beautiful objects for all to see.

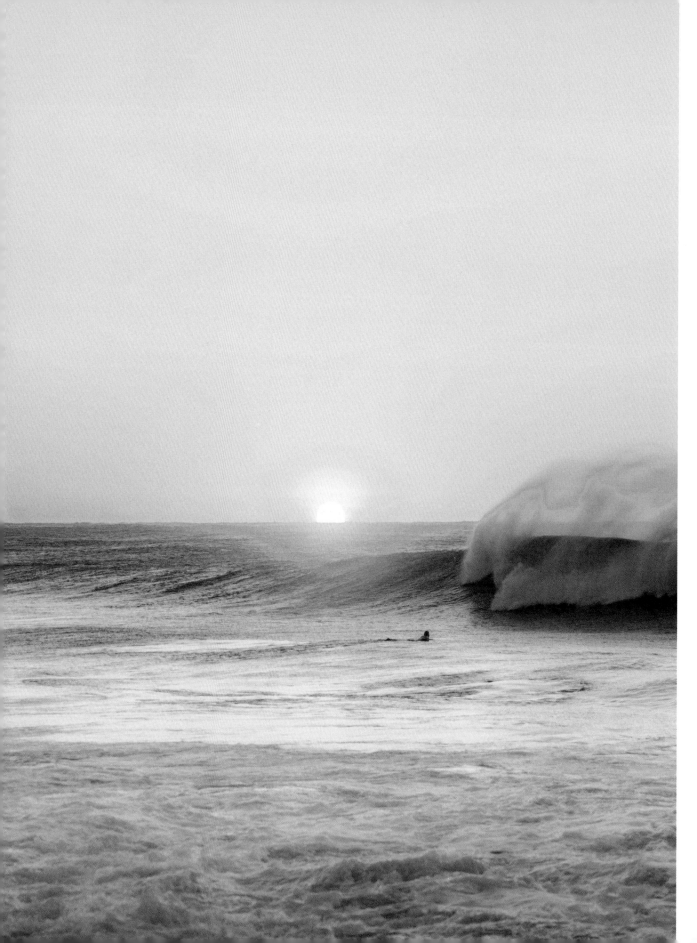

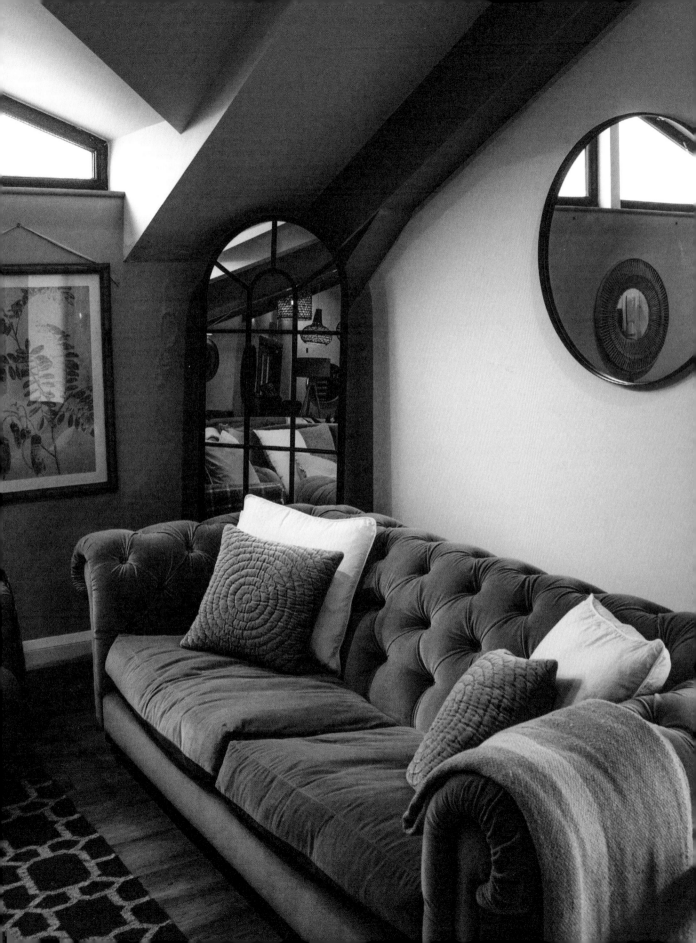

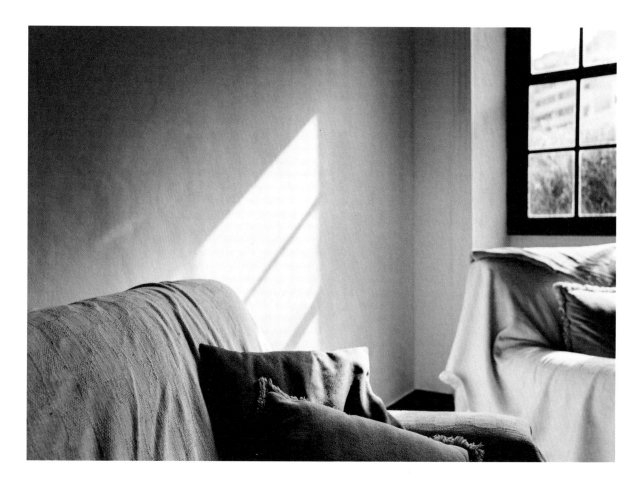

Choosing soft furnishings in muted tones of grey, slate
and ash make a beach house feel cosy during winter.

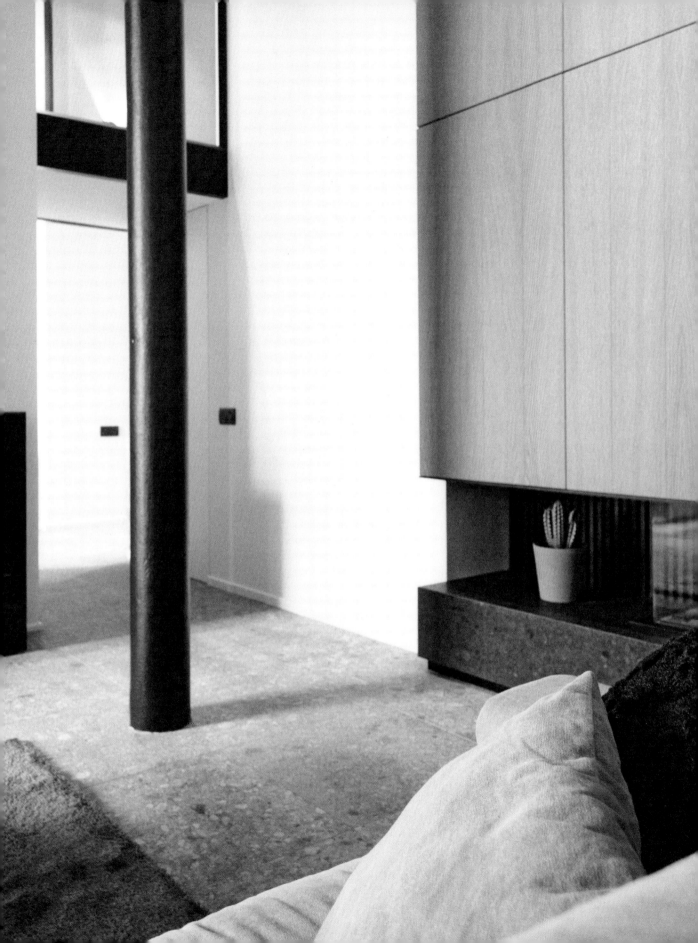

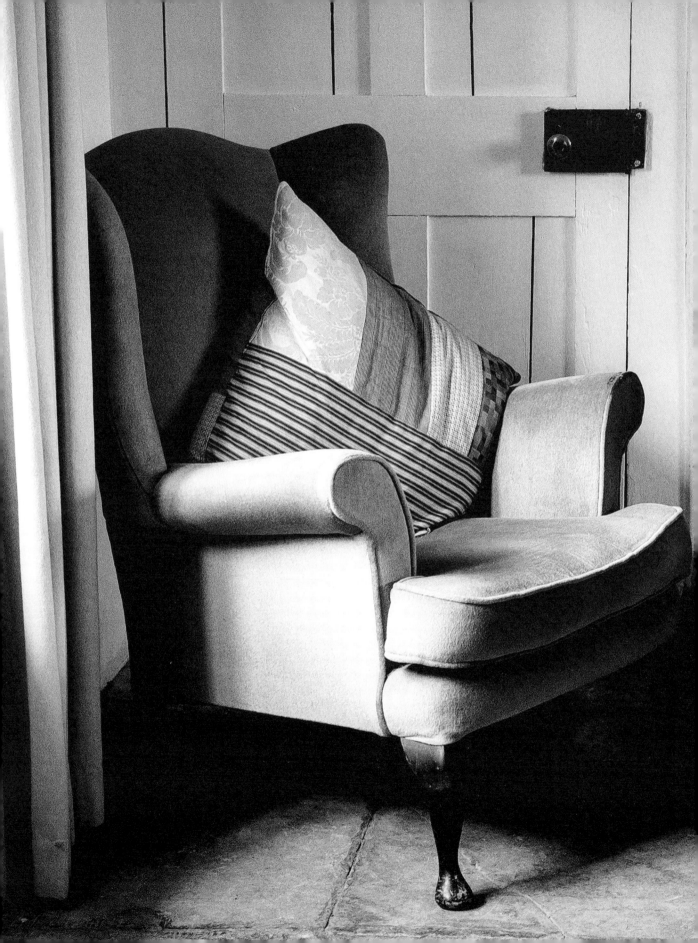

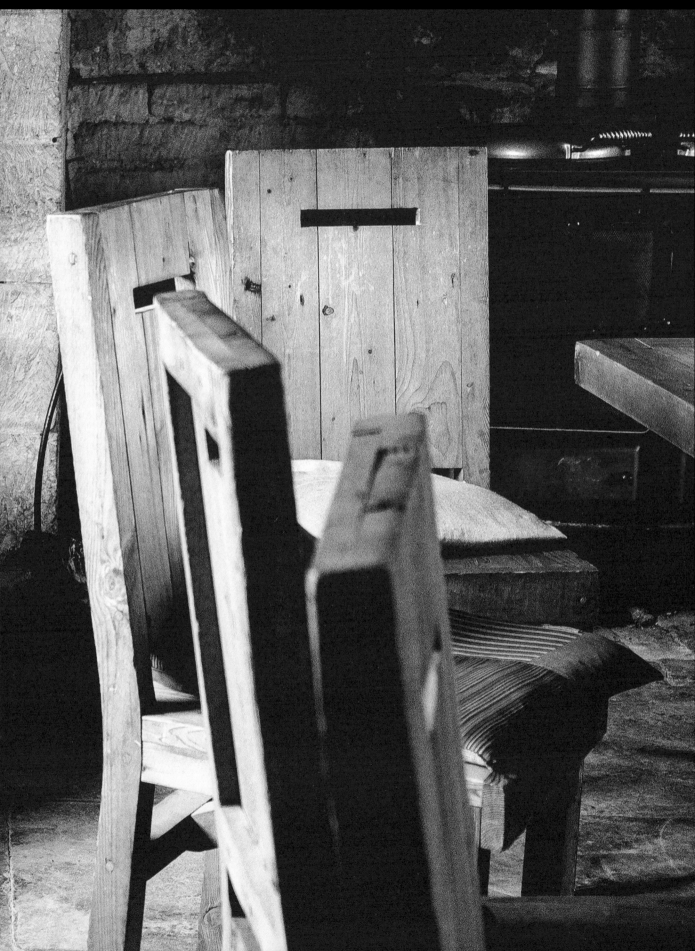

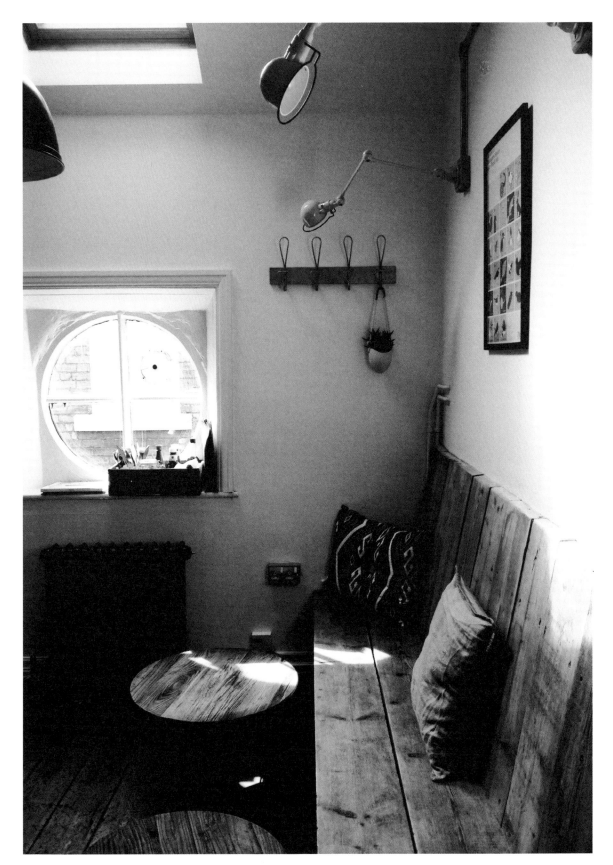

A porthole-shaped statement window evokes the feeling of living at sea.

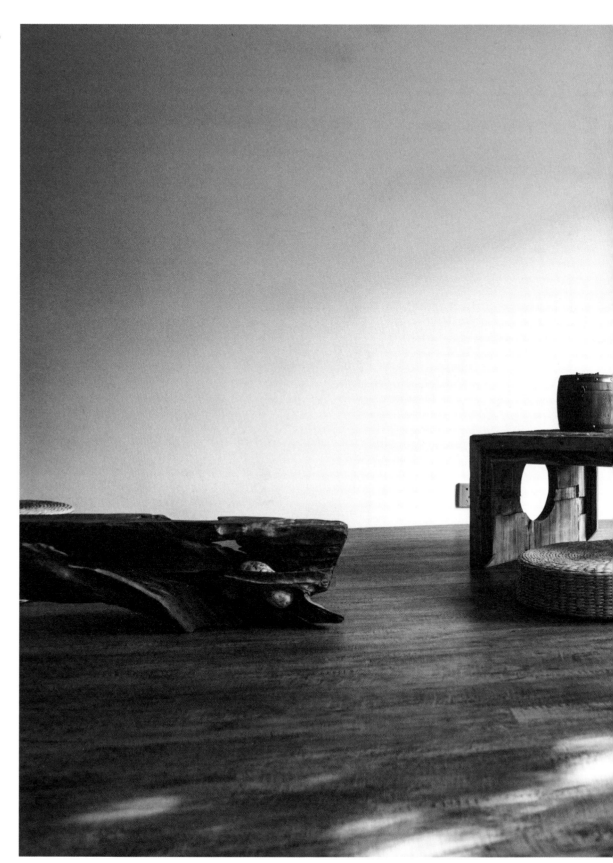

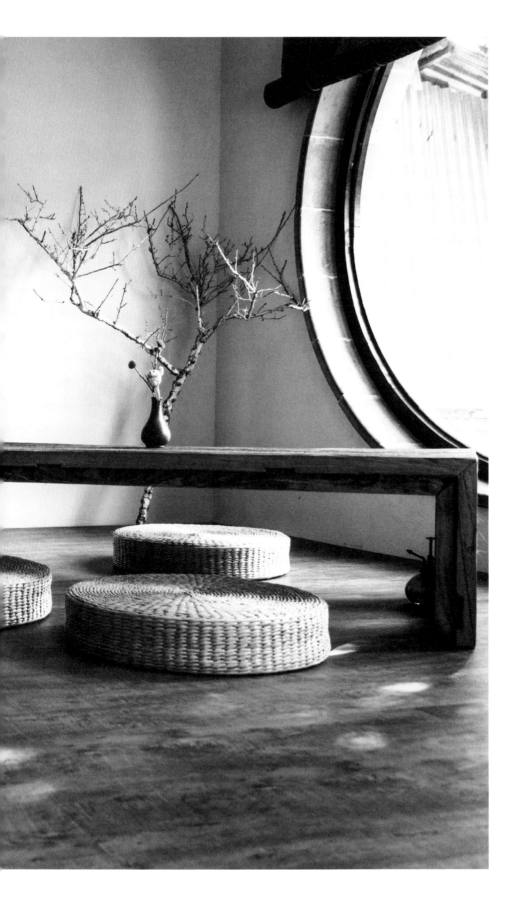

A variety of reclaimed, foraged and hand-crafted timber décor creates a natural, organic aesthetic.

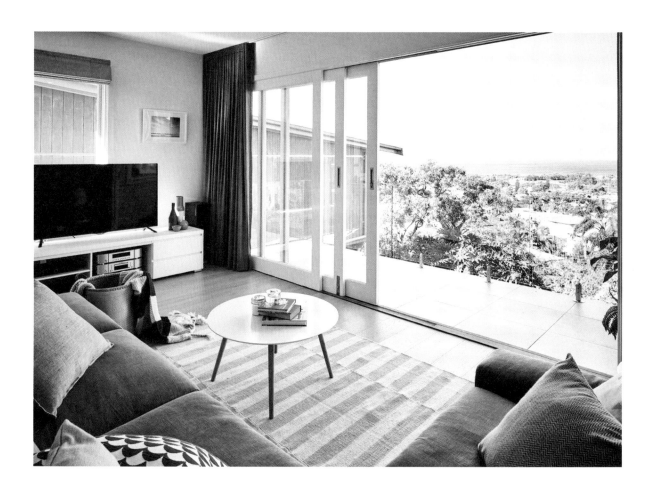

Embrace alfresco living by taking your living room outside.

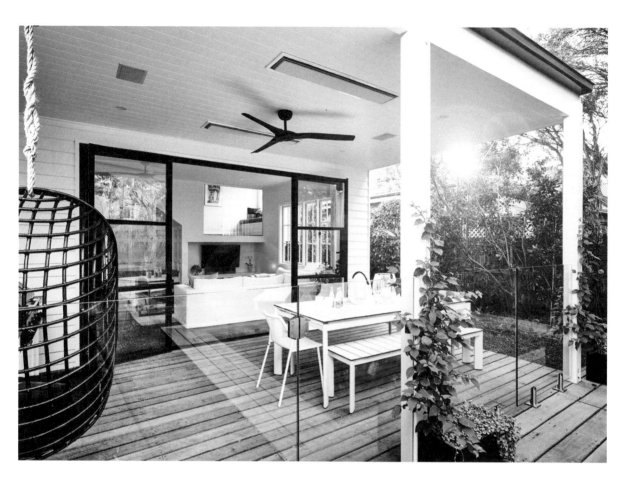

Open spaces and a ceiling fan make an outdoor living room a cool retreat in summer.

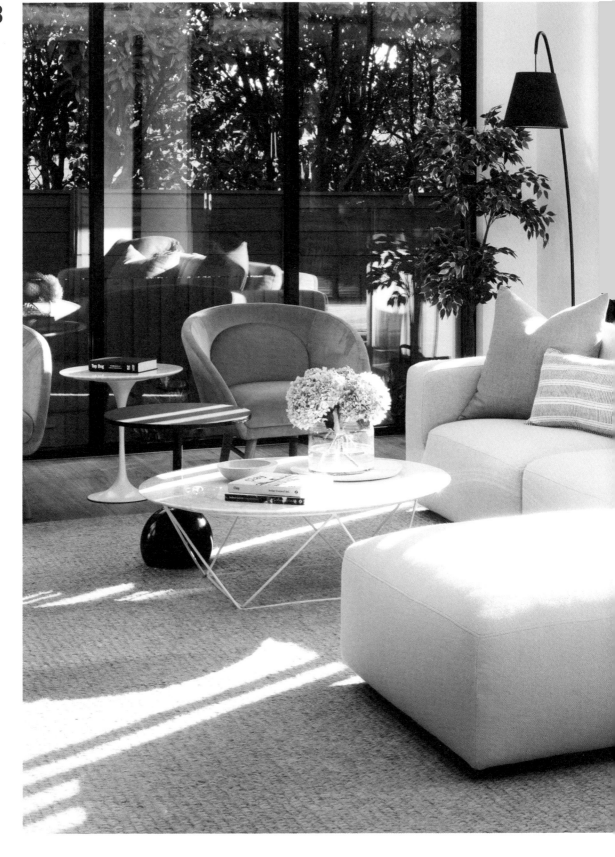

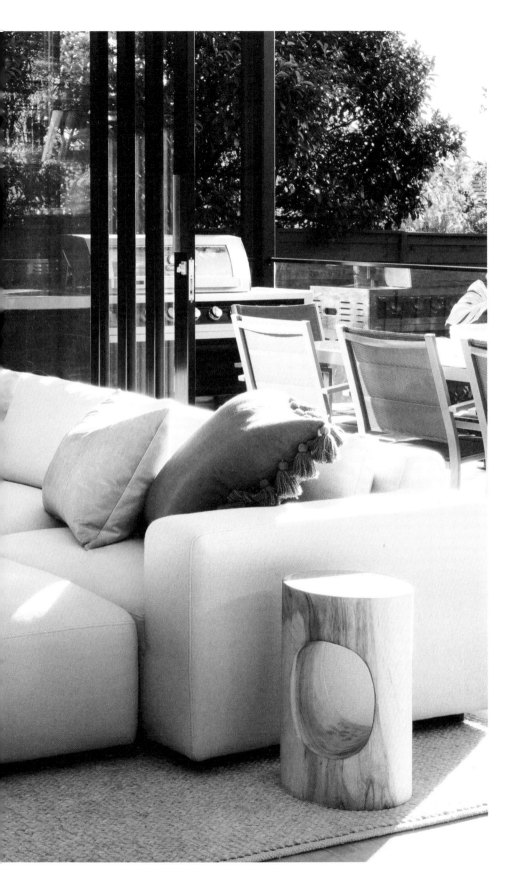

Floor-to-ceiling windows and glass sliding doors blur the lines between these indoor and outdoor living spaces.

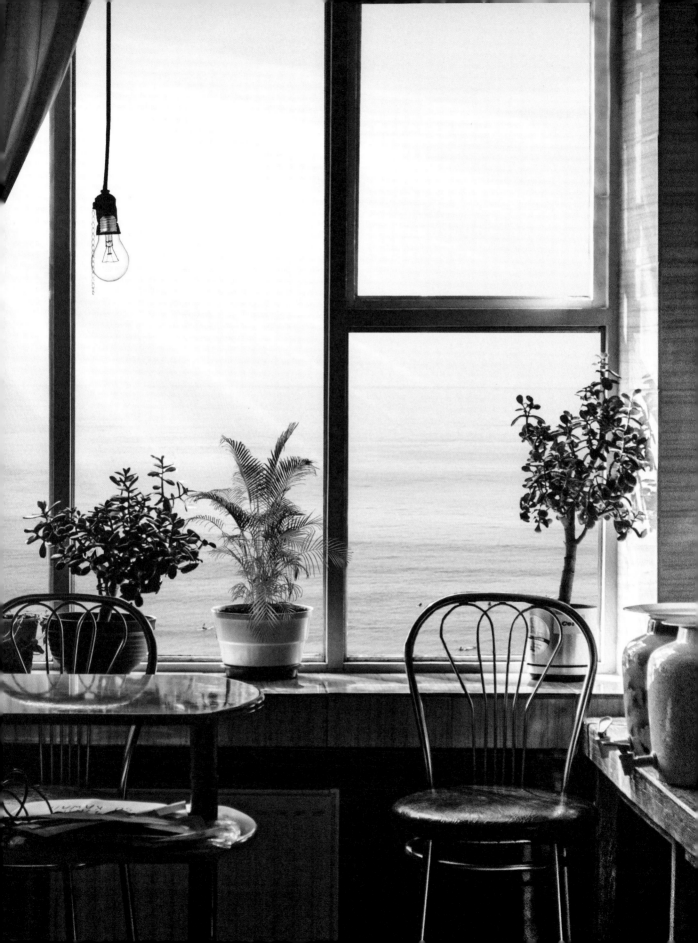

the kitchen

In many ways the kitchen is the engine room, the heart and soul of a home. A warm, familiar place where people come for nourishment and comfort, the beach house kitchen is a space to create, collaborate, share stories, clink glasses and break bread. A rustic piece of driftwood, a hardy coastal succulent in a pot, a collection of beloved seafood cookbooks, a reclaimed window frame with a view to the sea . . . invite your favourite elements of the ocean into your beach house kitchen to put your own stamp on this room.

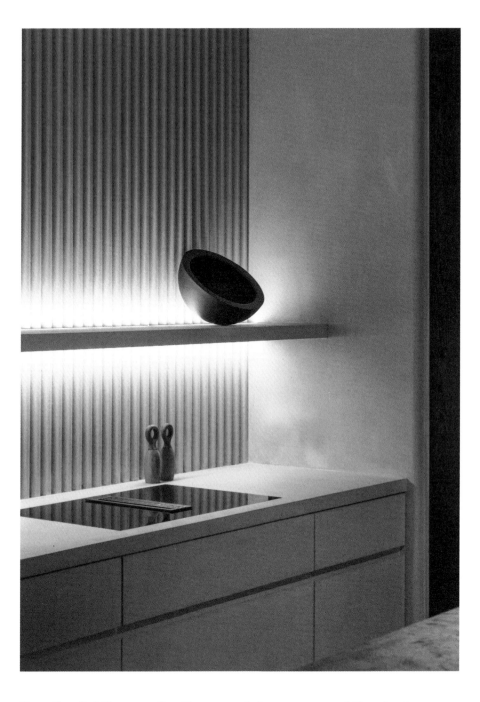

Creative lighting applications can bring a sense of theatre to your kitchen. Shelf lighting casts a warm glow over the room instead of the stark brightness of conventional kitchen downlights.

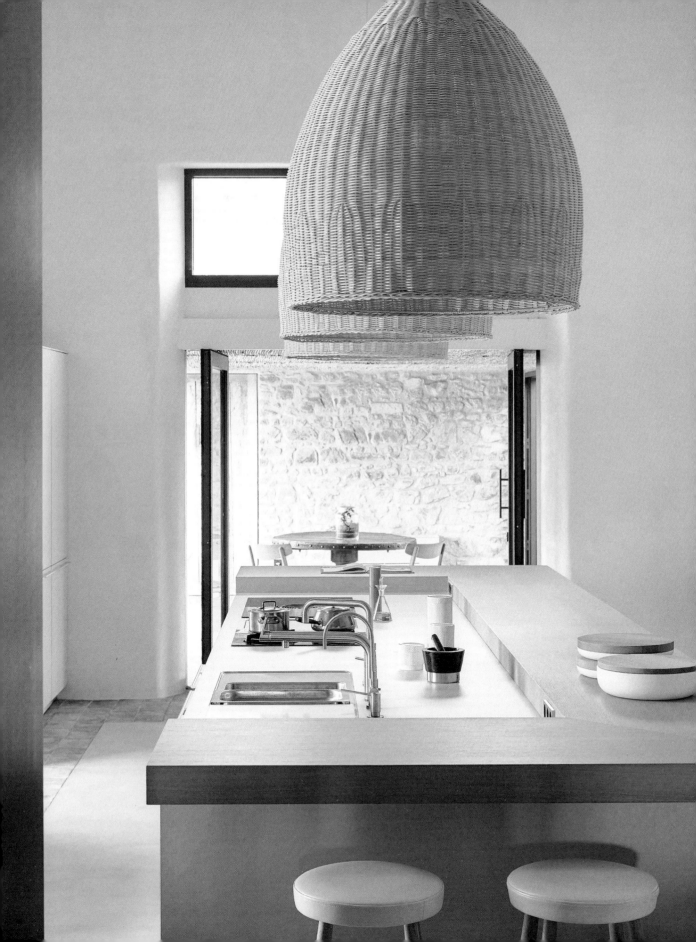

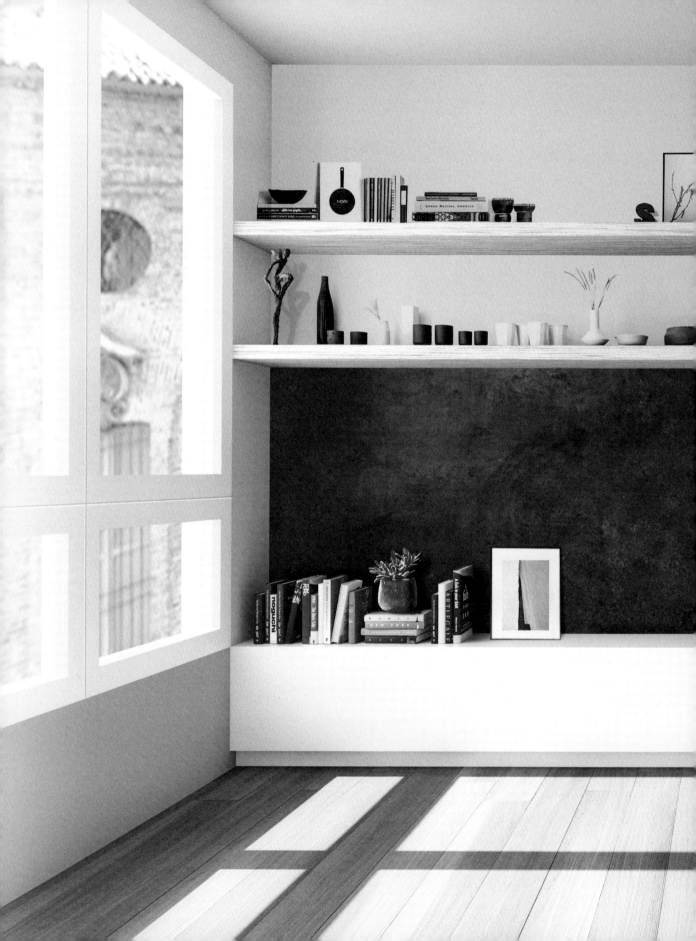

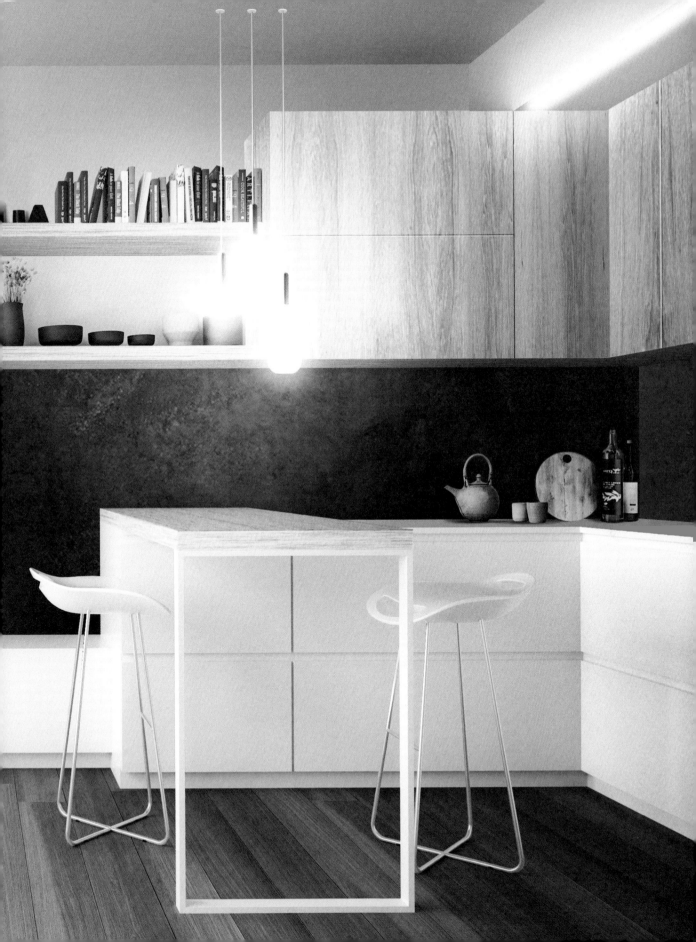

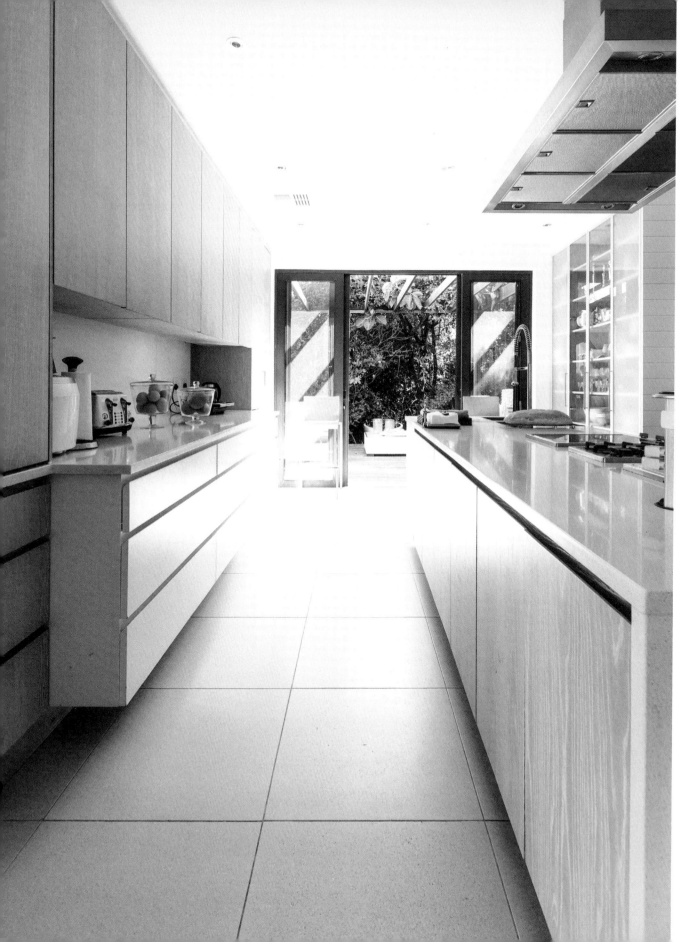

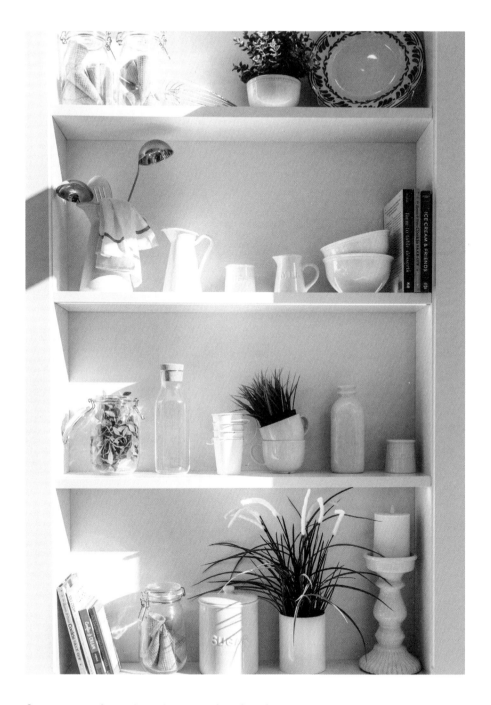

Store your functional, everyday kitchenware in closed cupboards and drawers while displaying aesthetically pleasing pieces on open shelves.

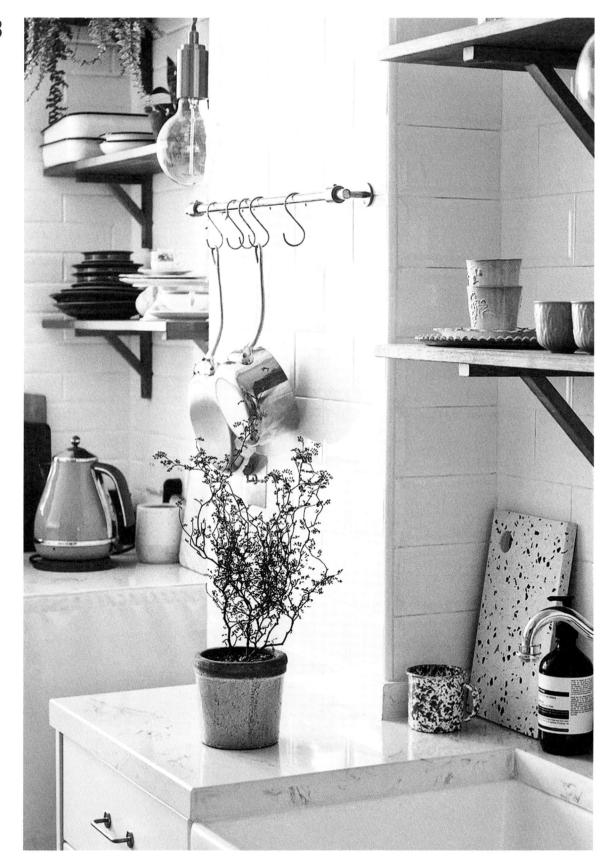

A small piece of nature has the power to transform an entire room.

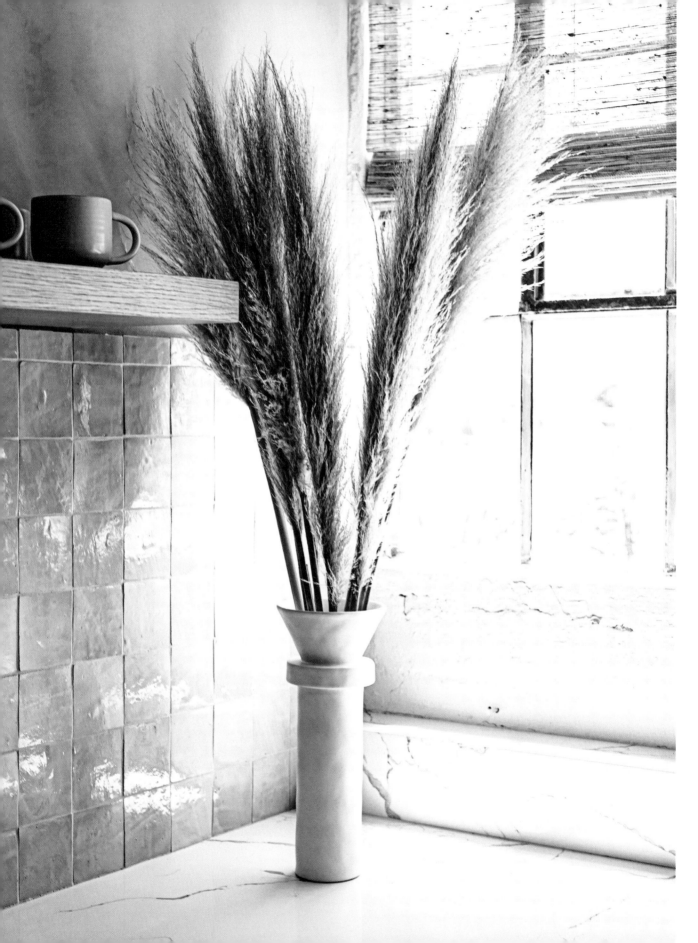

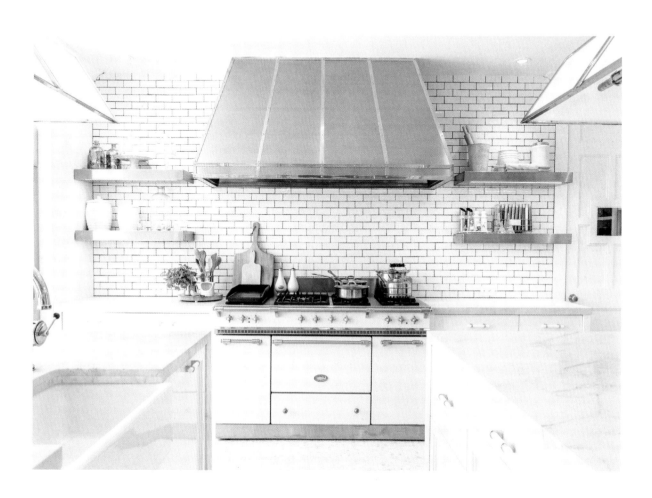

Versatile subway tiles are an enduring classic. Used horizontally, these tiles brighten the room, mirroring shapes across the kitchen.

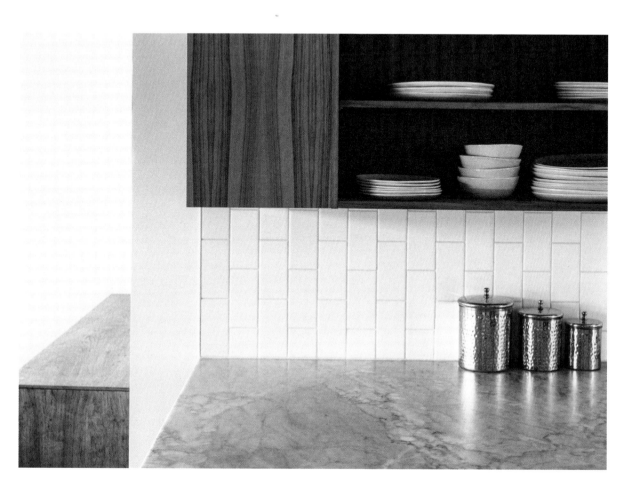

When applied vertically, subway tiles can fill awkward spaces
in the kitchen, creating the perception of height.

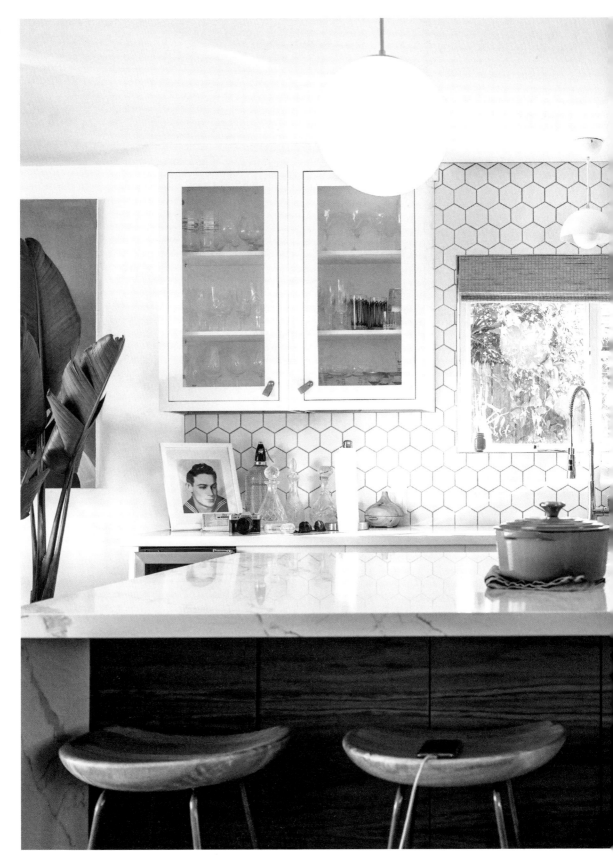

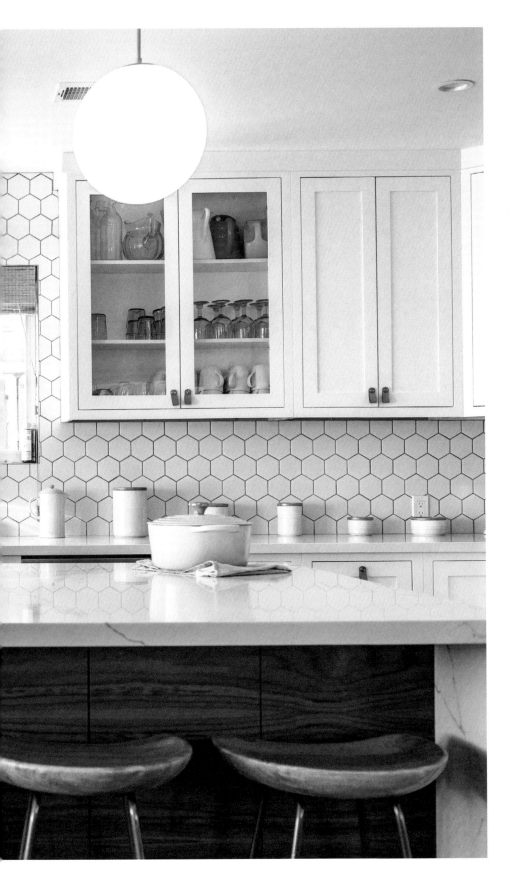

With a shape reminiscent of honeycomb, hexagonal tiles take this kitcken from ordinary to extraordinary.

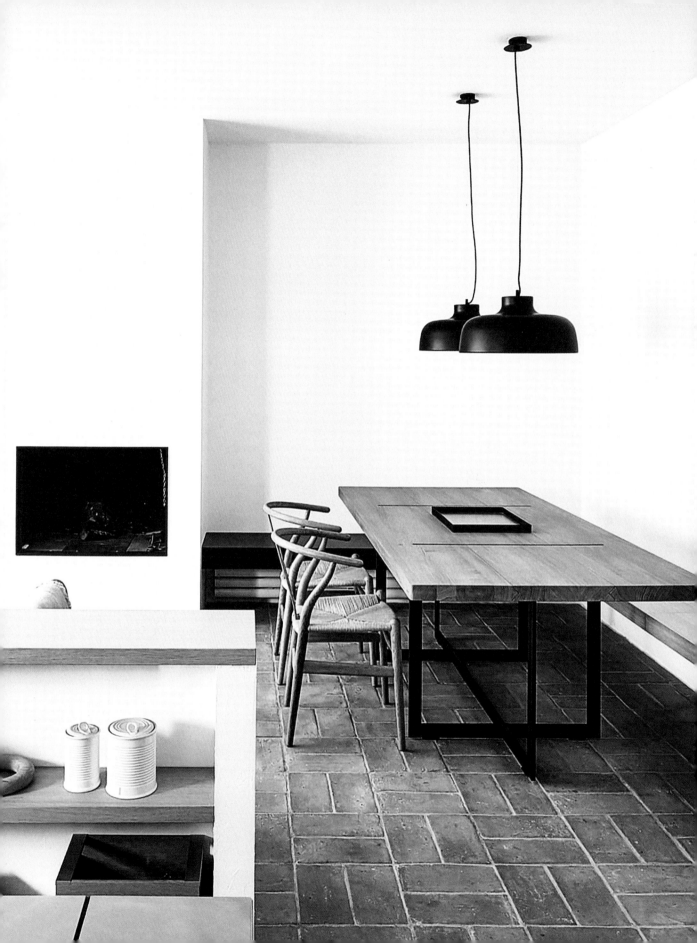

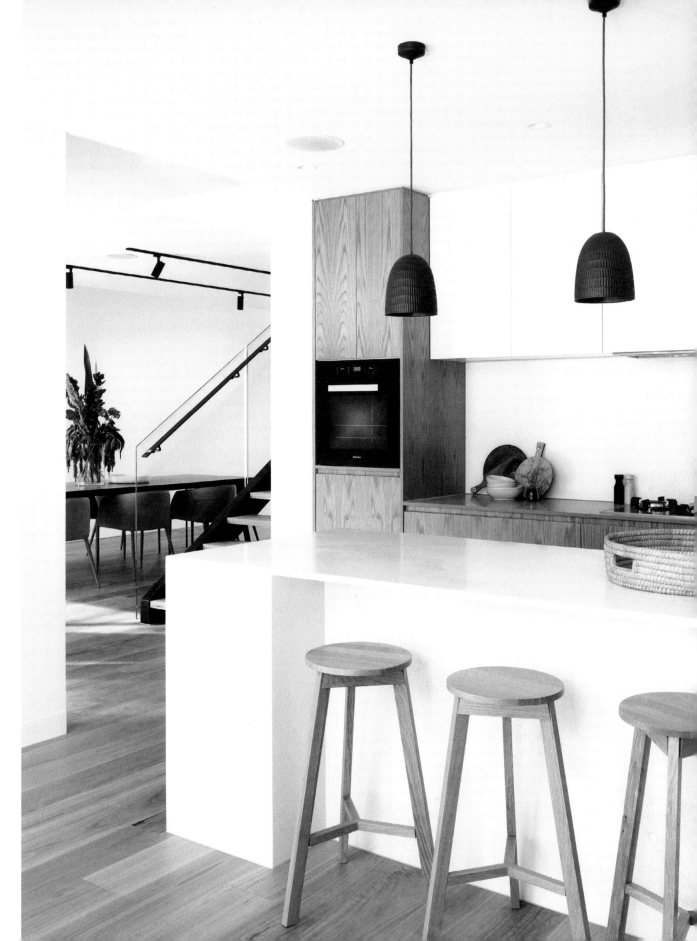

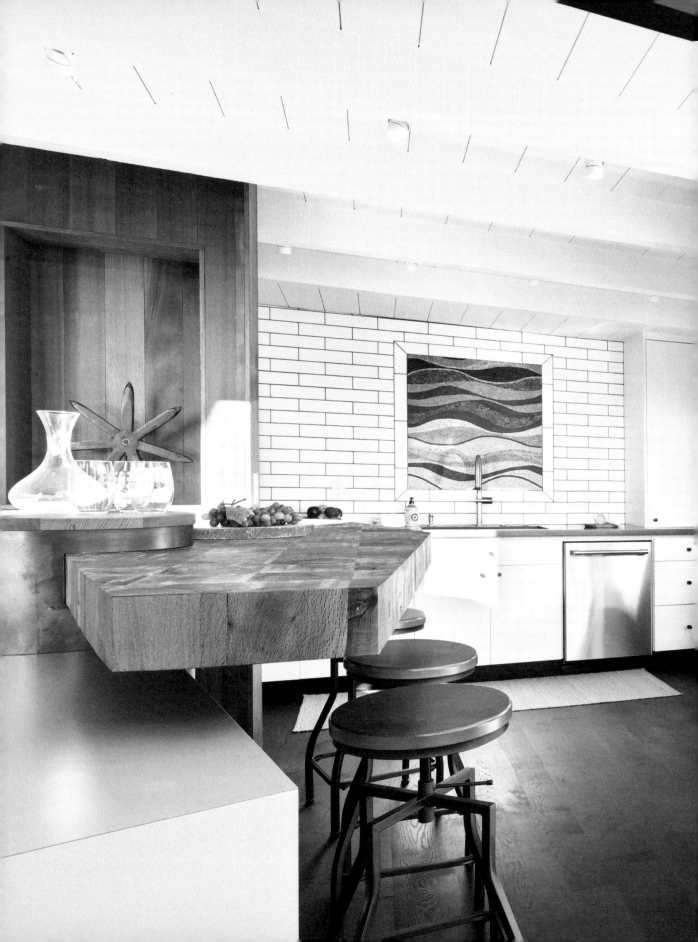

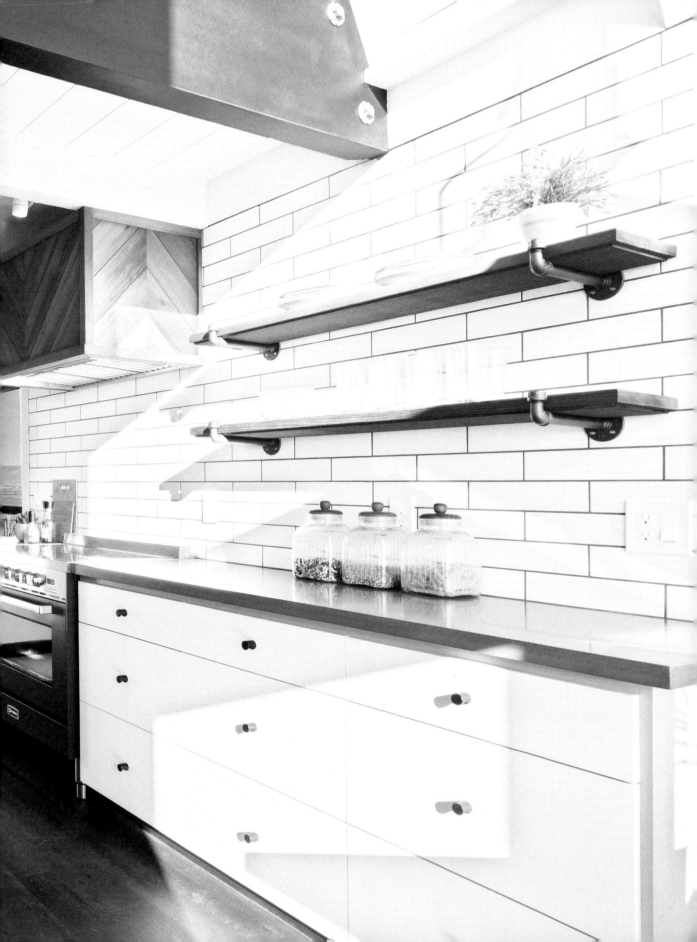

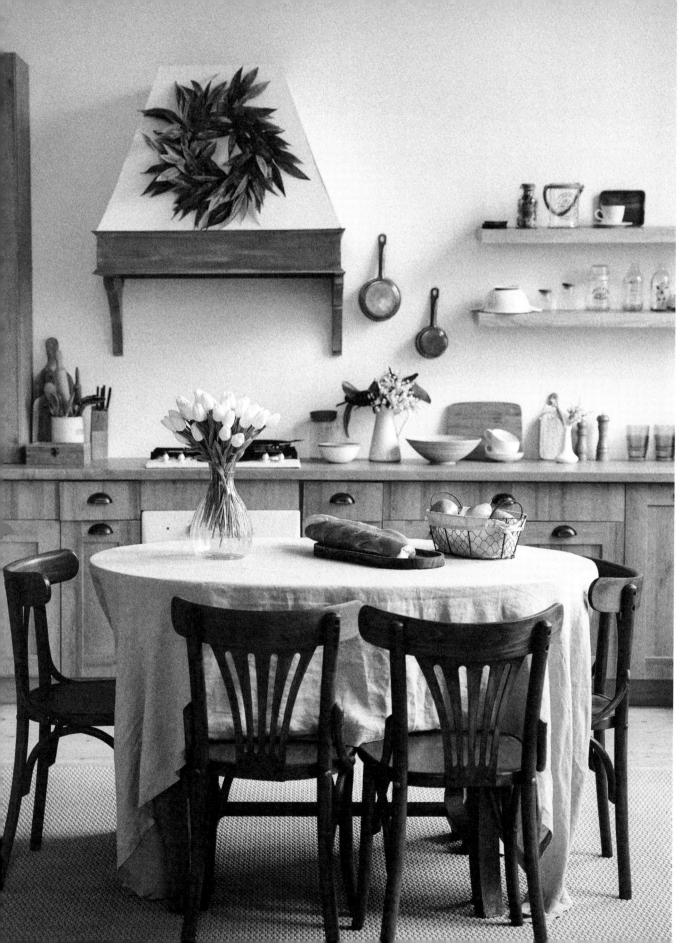

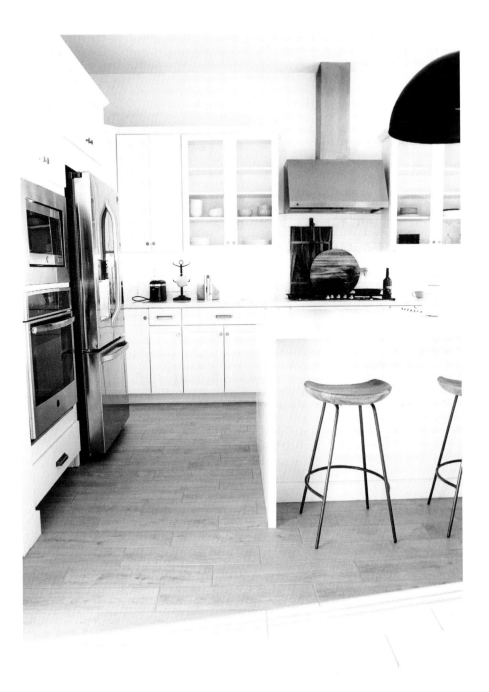

Whether farmhouse style, bentwood, wishbone or ladder back, handcrafted timber chairs are a traditional seating choice that will stand the test of time.

Brighten a space by layering with different shades of white.

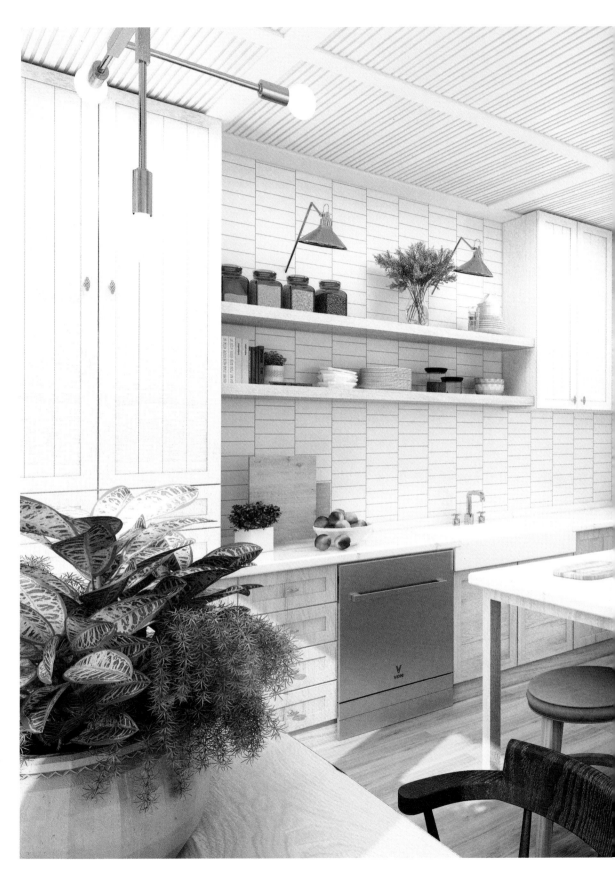

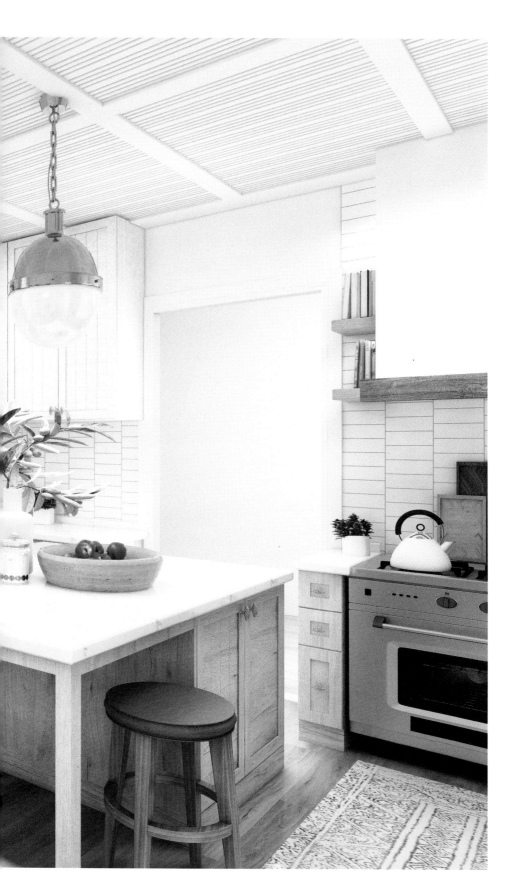

Small details can evoke nautical elements; the chain on this metallic light fitting is similar to that found on a ship's anchor.

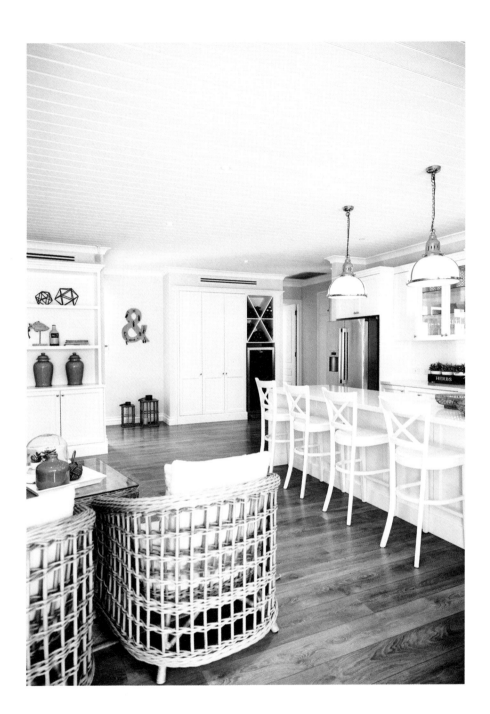

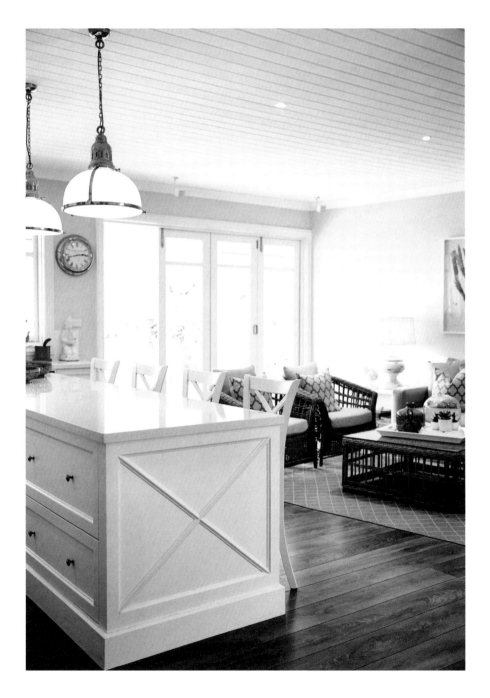

A white countertop and pendant lamps with a metallic edge
is an enduring kitchen style with a nod to the nautical.

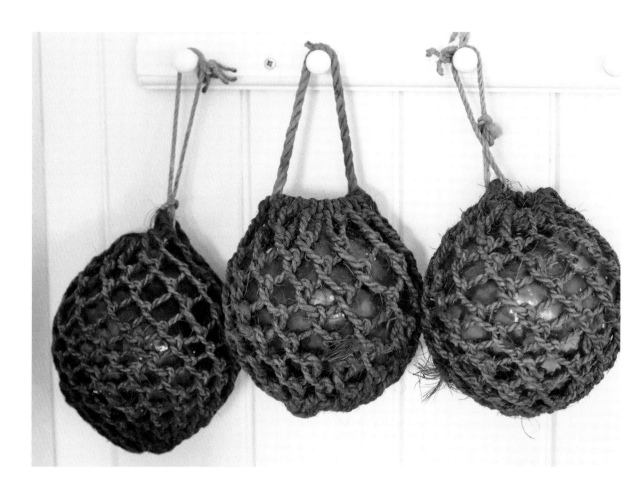

Showcasing favourite pieces in open storage provide an artful use of space.

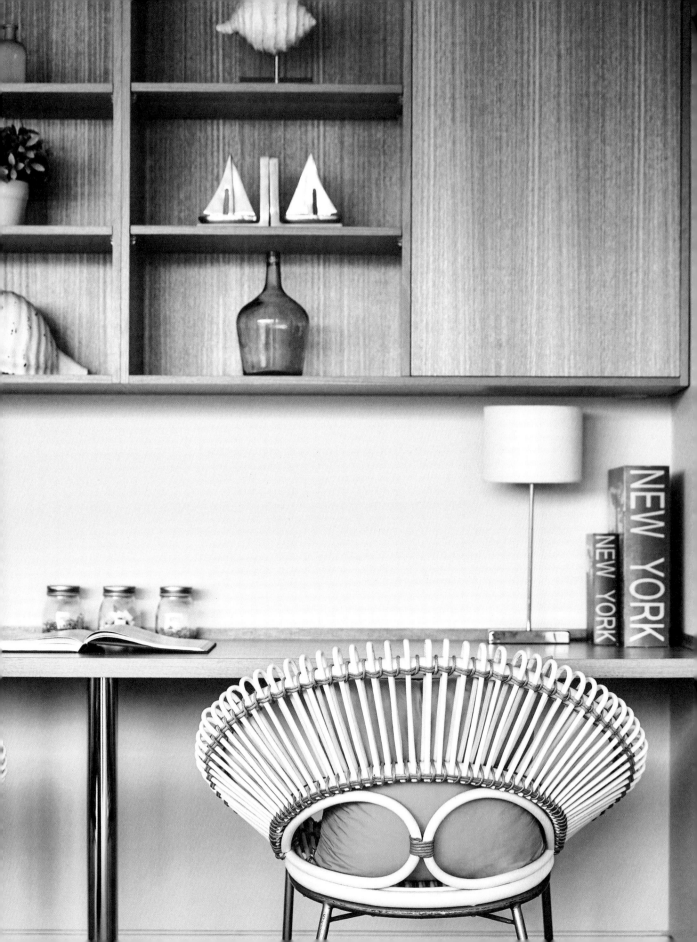

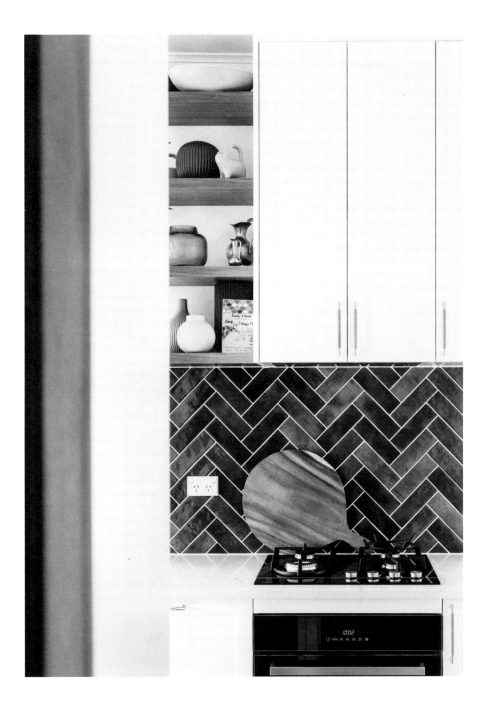

Mixing open and closed storage space in one unit is a practical and visually appealing choice.

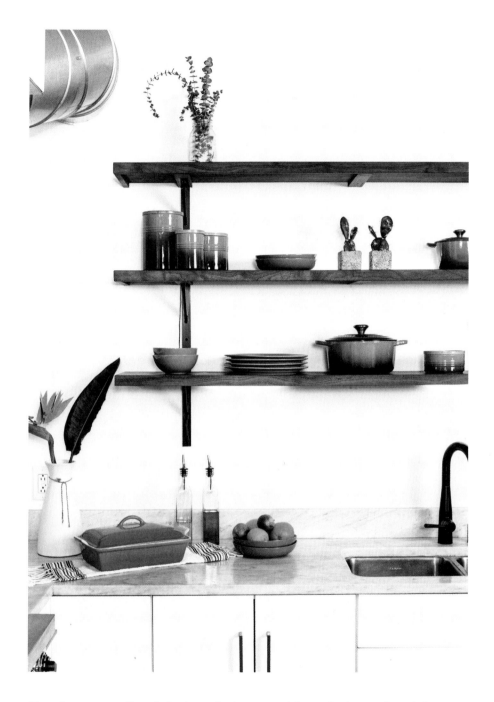

Simple, streamlined timber shelves positioned above the sink
marries form with function.

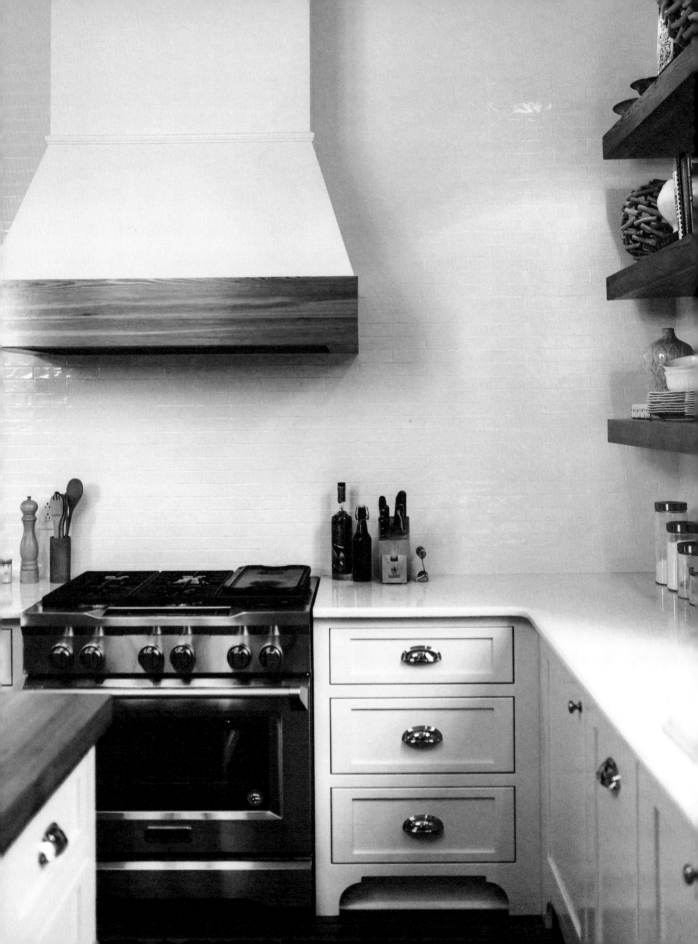

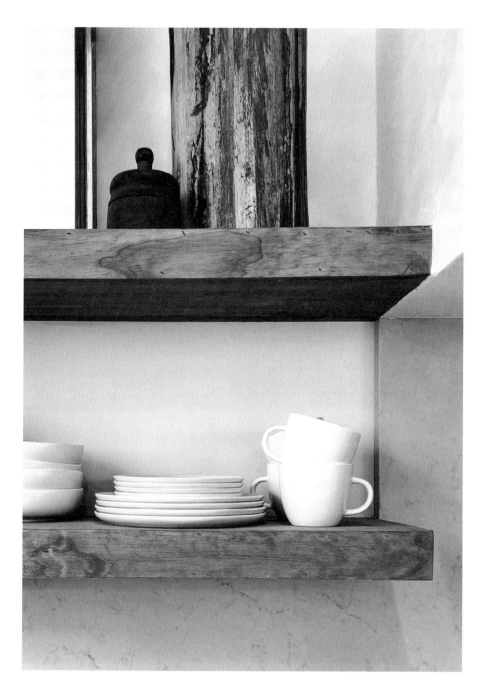

Storing everyday items on open shelves at a low height means your favourite coffee cup is just an arm's length away.

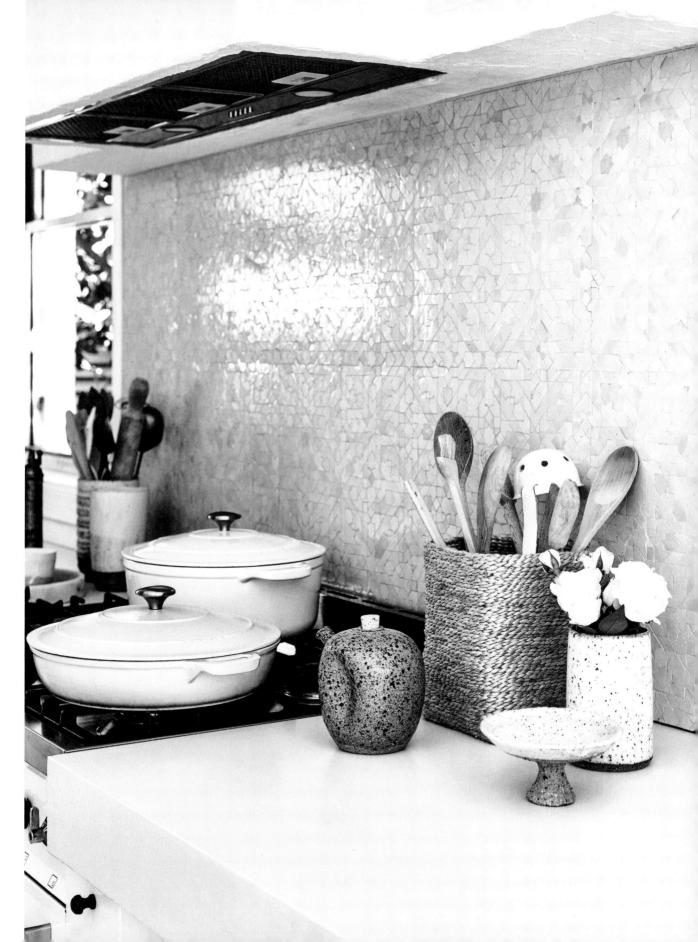

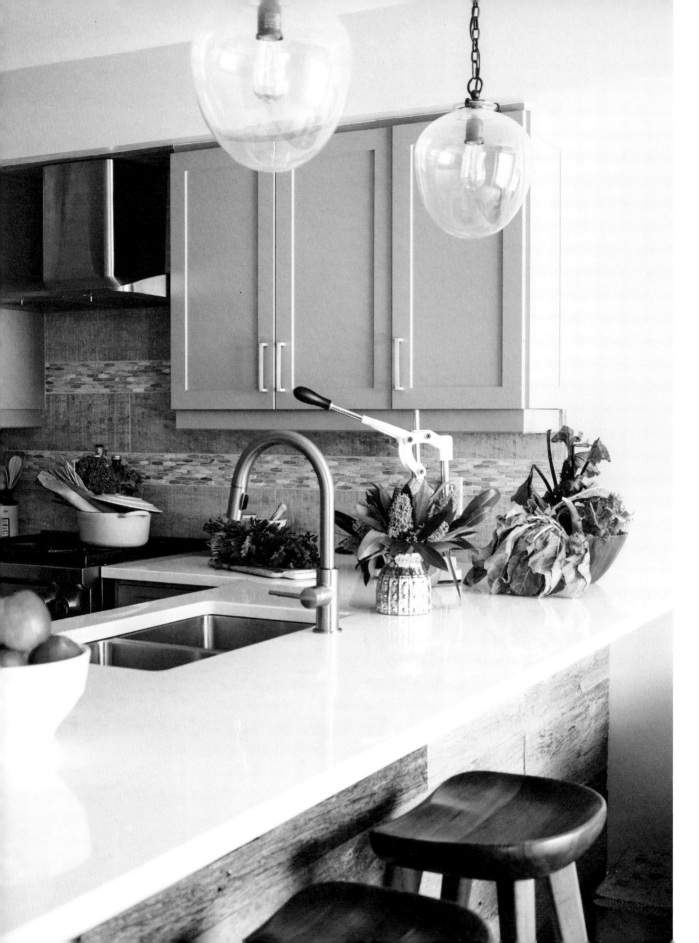

A panel of feature tiles brings some colour and interest to the kitchen.

Light sage hues evoke memories of collecting sea glass on the shore.

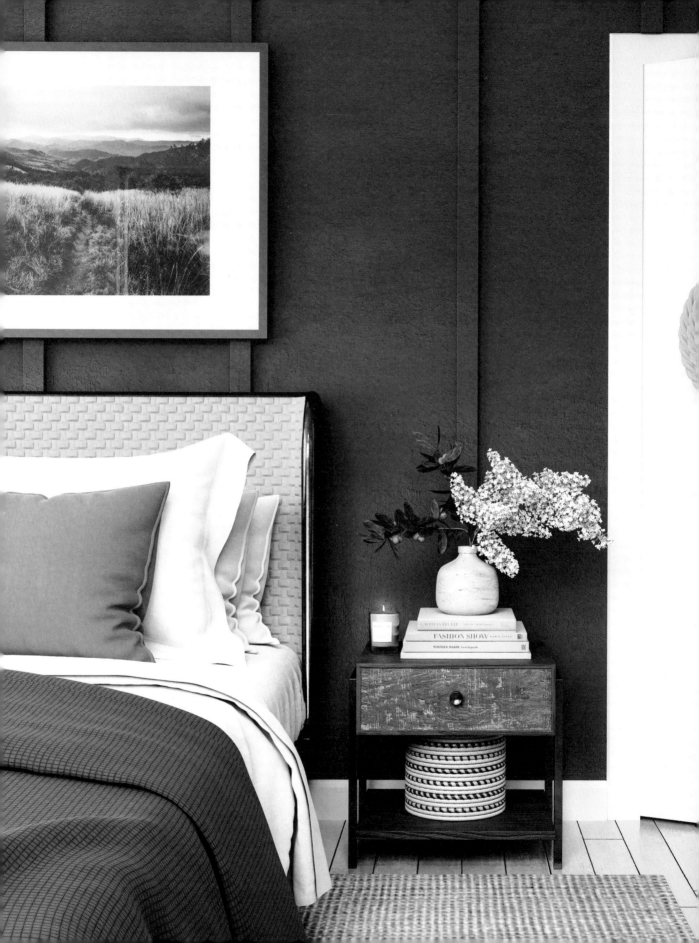

the bedroom

So much more than a place to sleep, the bedroom should be your peaceful refuge from the world. To create a beach house bedroom, start with a clean, simple design, then elevate the space with personal touches such as luxe soft furnishings, art inspired by nature and aromatic candles infused with the scents of the sea. The best bedrooms are comforting, calm spaces where resting, napping and dreaming come easily. Invest in luxury linen, cloud-like mattress toppers, plush pillows and all the other essentials befitting such a sacred sanctuary. When it comes to styling your ultimate beach house bedroom, dream big.

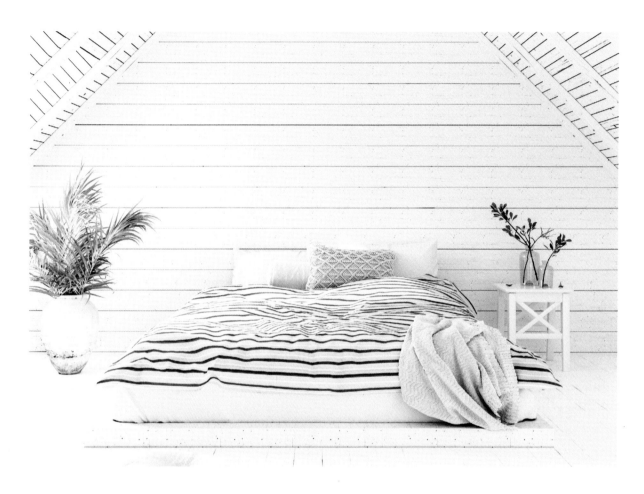

An open-plan bedroom creates a feeling of spaciousness while bathing the room in natural light all year round.

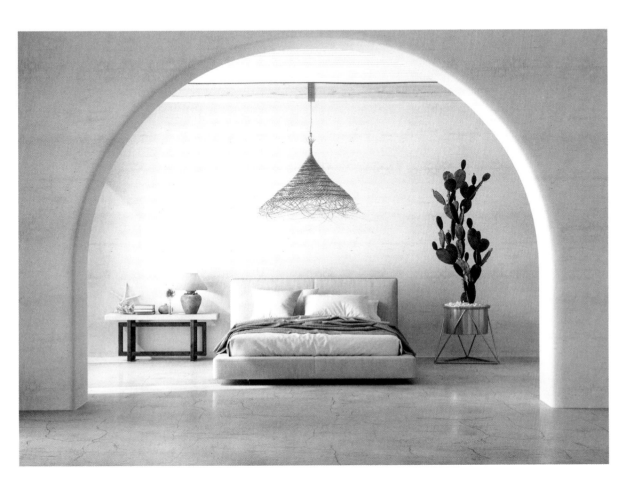

Bring a Zen-like feel to a beach house bedroom with white walls and minimal decoration, transforming it into a sanctuary for sleep.

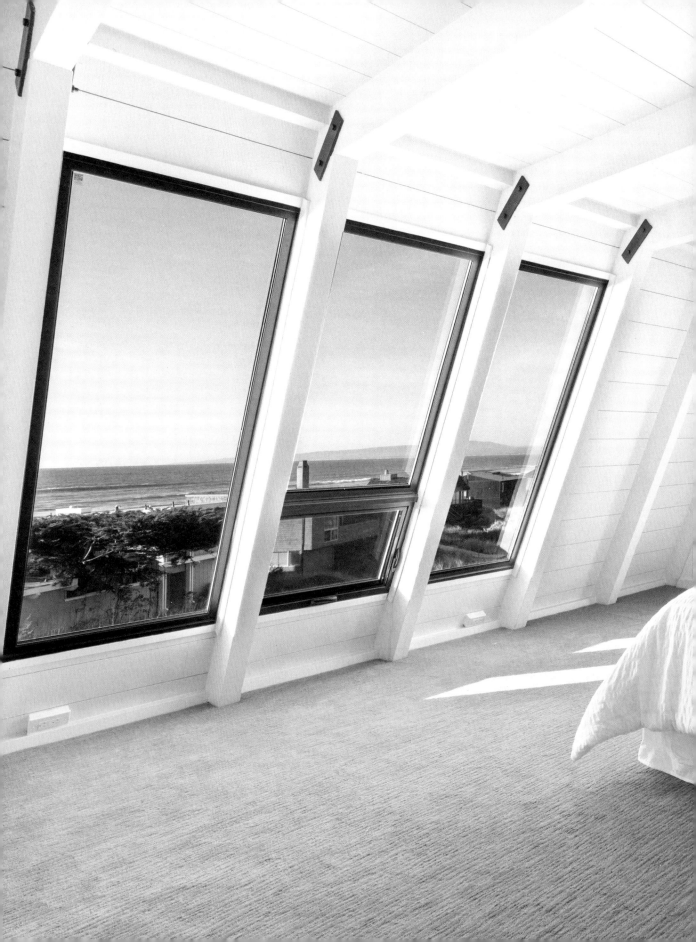

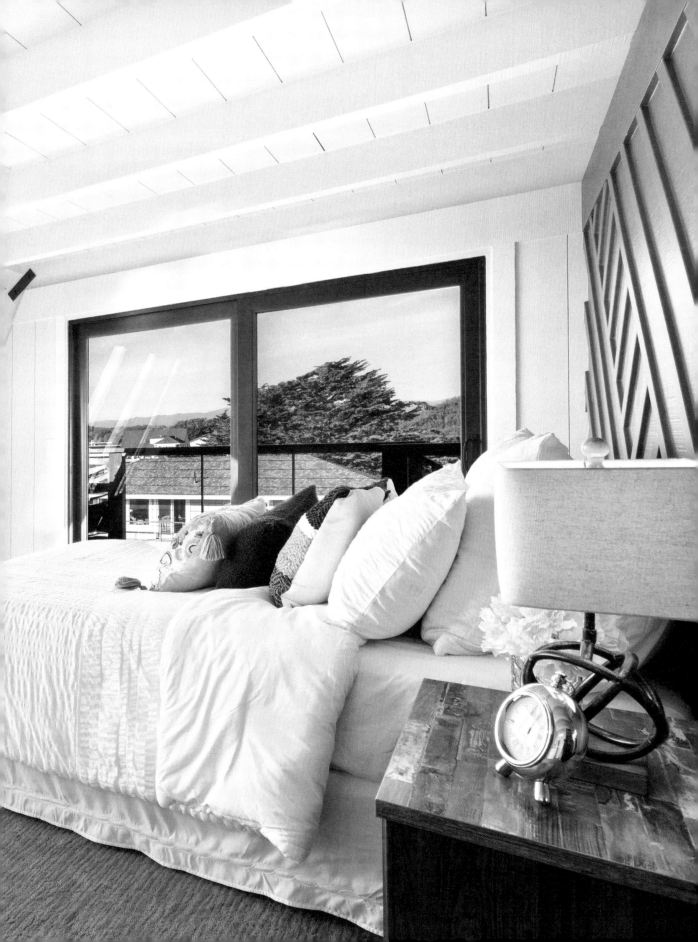

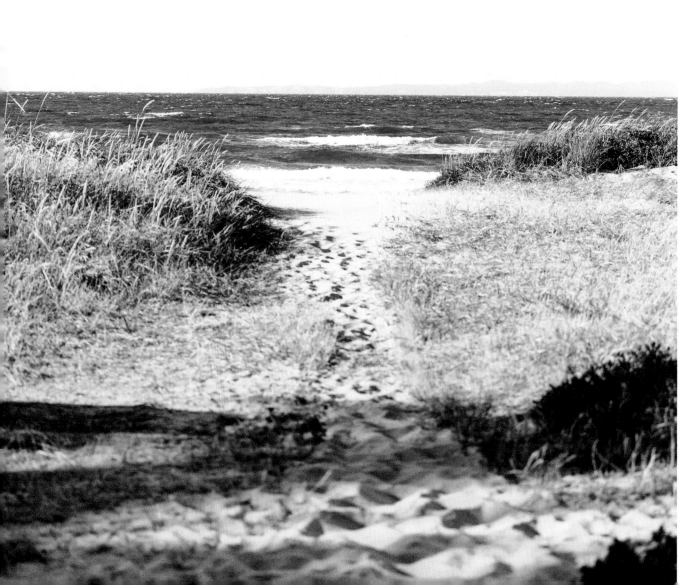

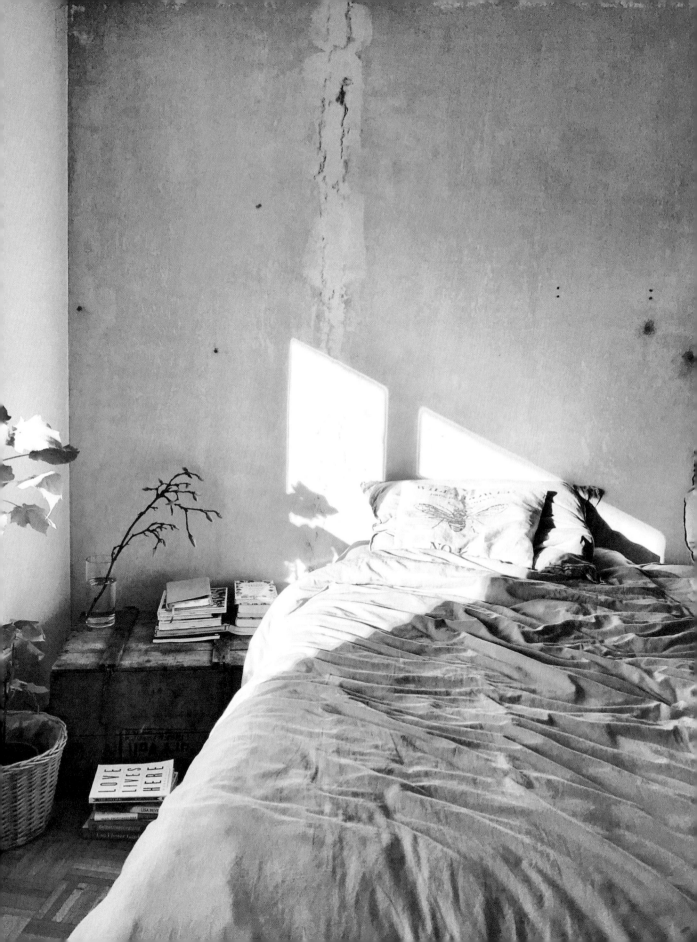

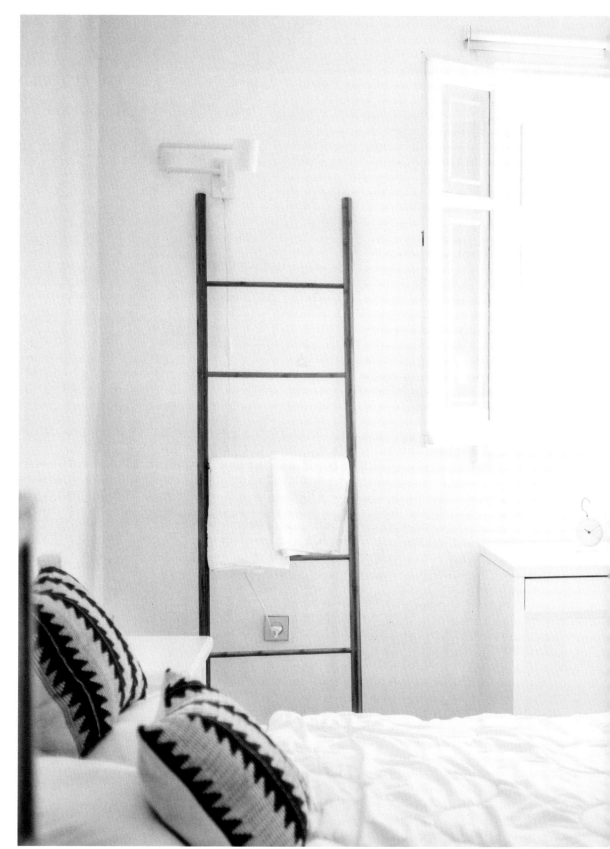

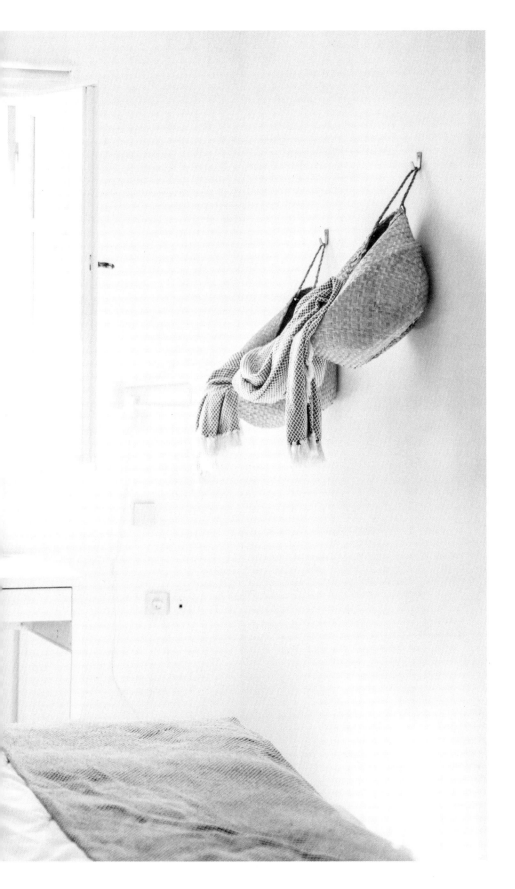

Simple decorative items made from natural materials like seagrass add a touch of the coast to an understated beach house bedroom.

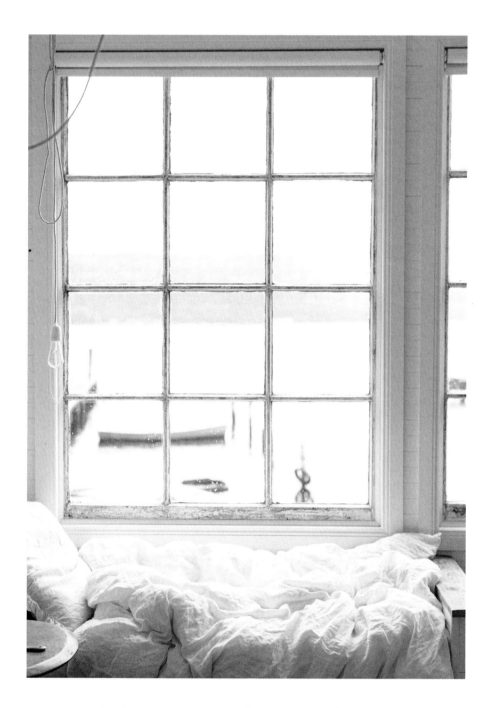

Wall art isn't always necessary when you're living by the sea.
A well-crafted timber window frame exposing tranquil water
views acts as a focal point for the room.

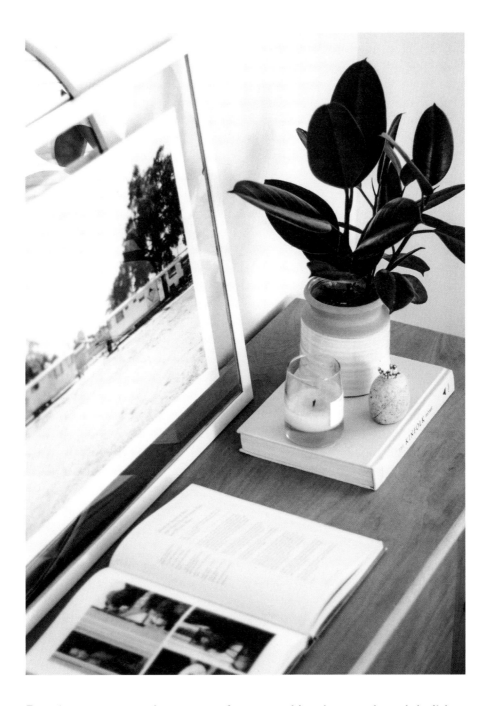

Framing a treasured memory of a coastal landscape, beach holiday or local vista brings the beach right into your bedroom.

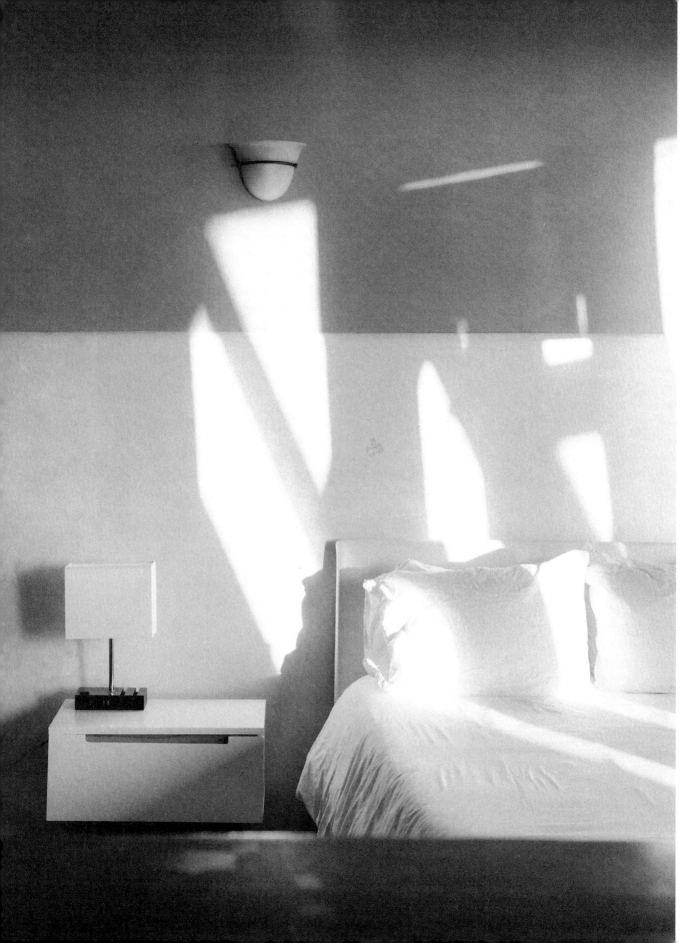

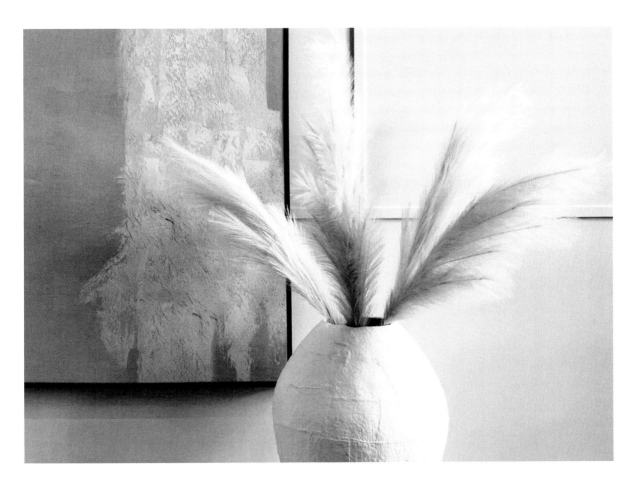

Cosy tones of peach, salmon and blush bring a serene, endless summer vibe to sleeping spaces; these hues foster warmth, tenderness and intimacy.

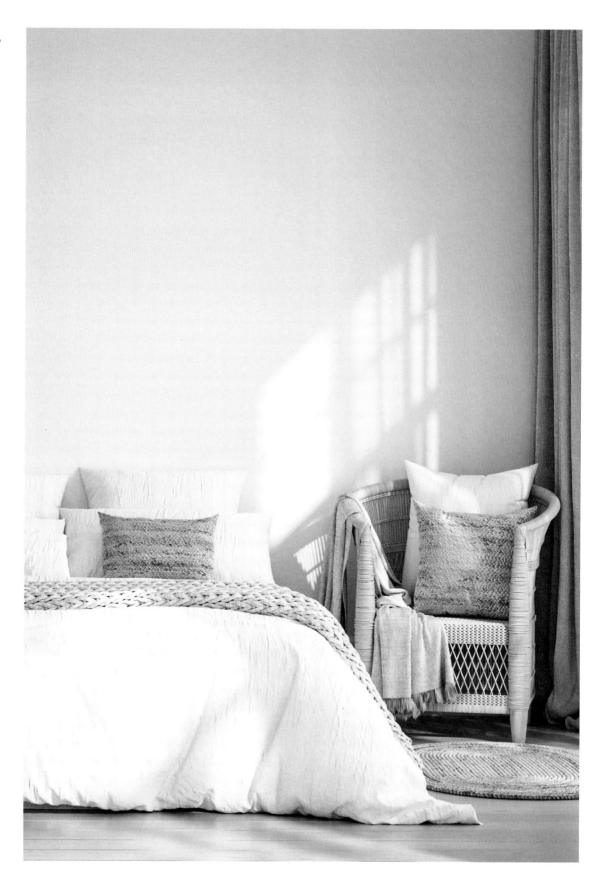

Woven natural materials conjure memories of the coast.

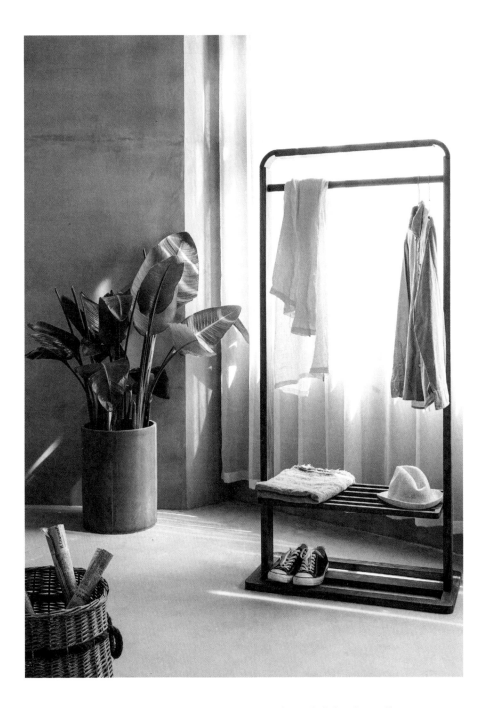

The clever contrast among textural, industrial-look walls; jade-green plant leaves; and soft, natural fabrics makes this a one-of-a-kind beach house bedroom.

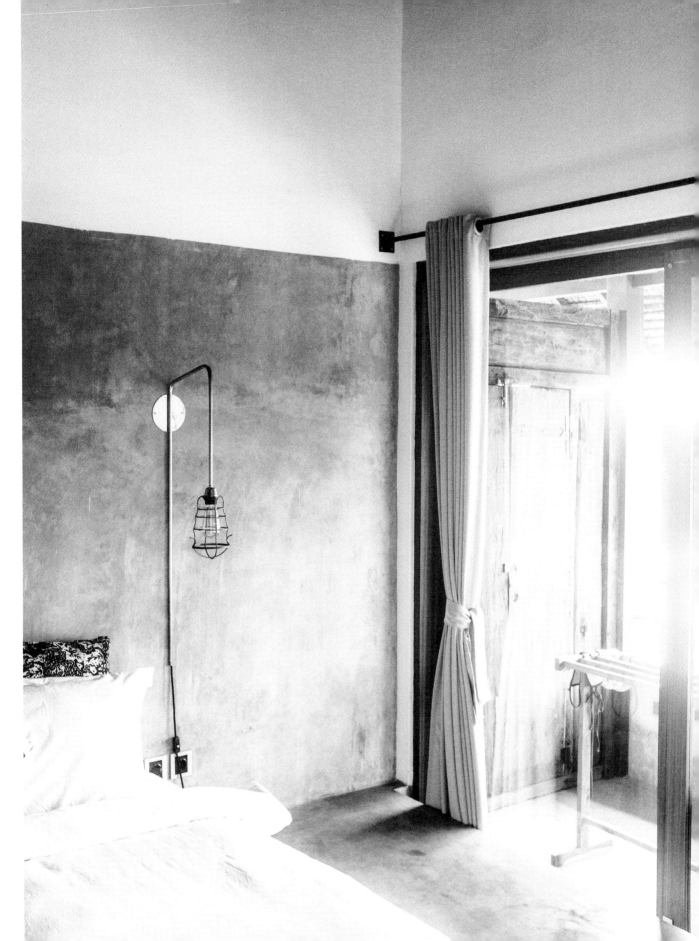

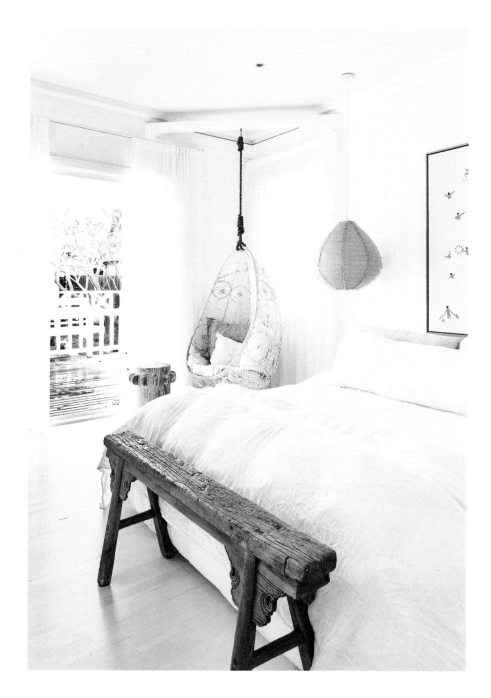

A vintage timber bench speaks to the texture of driftwood without overpowering the space.

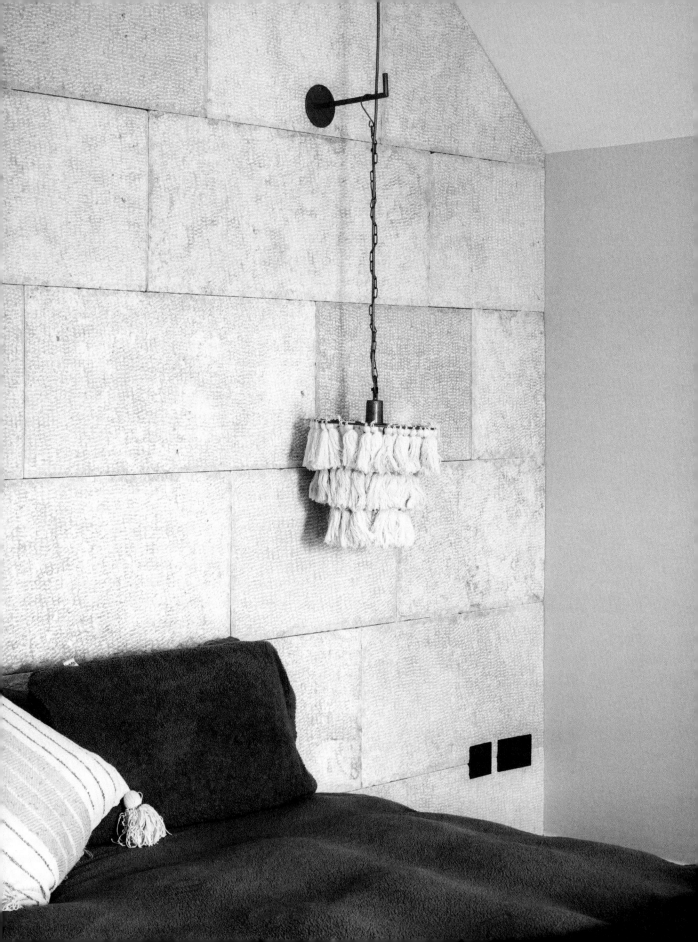

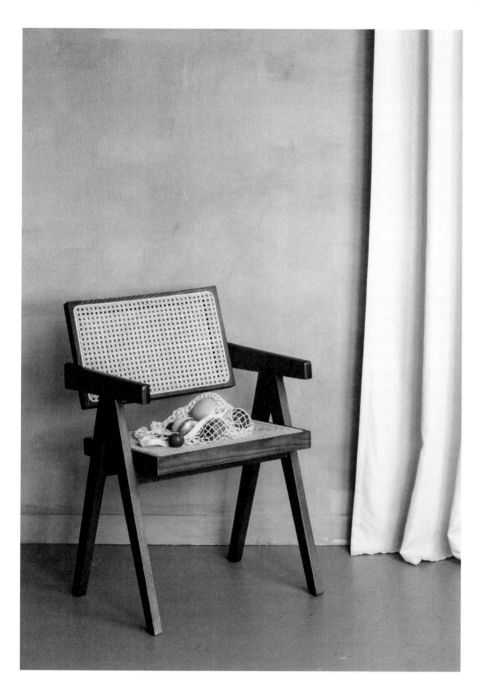

Experiment with introducing a variety of different textures to add
a tactile element of surprise to your sleeping space.

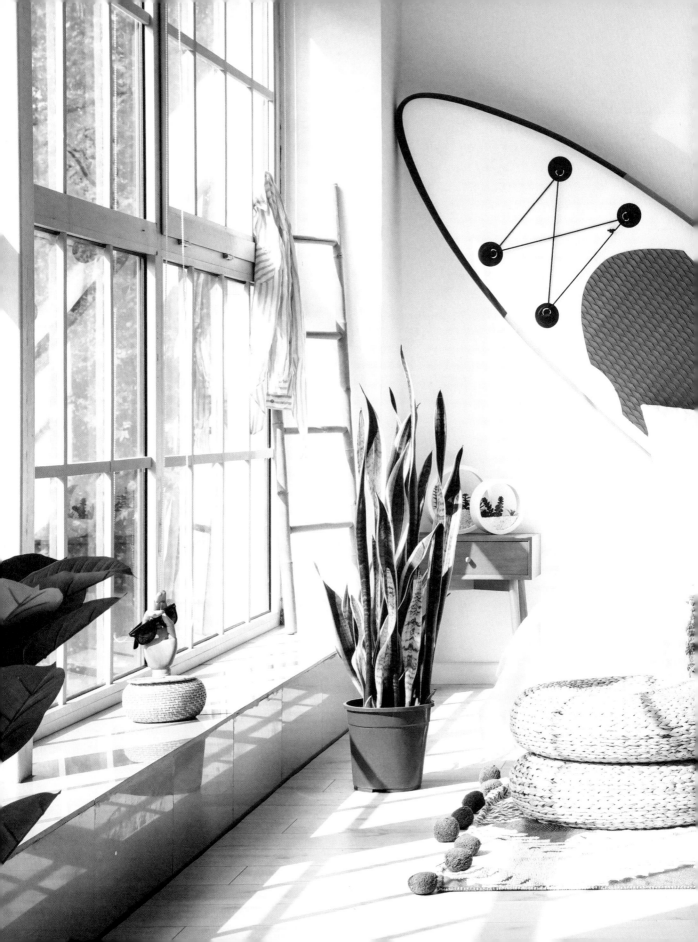

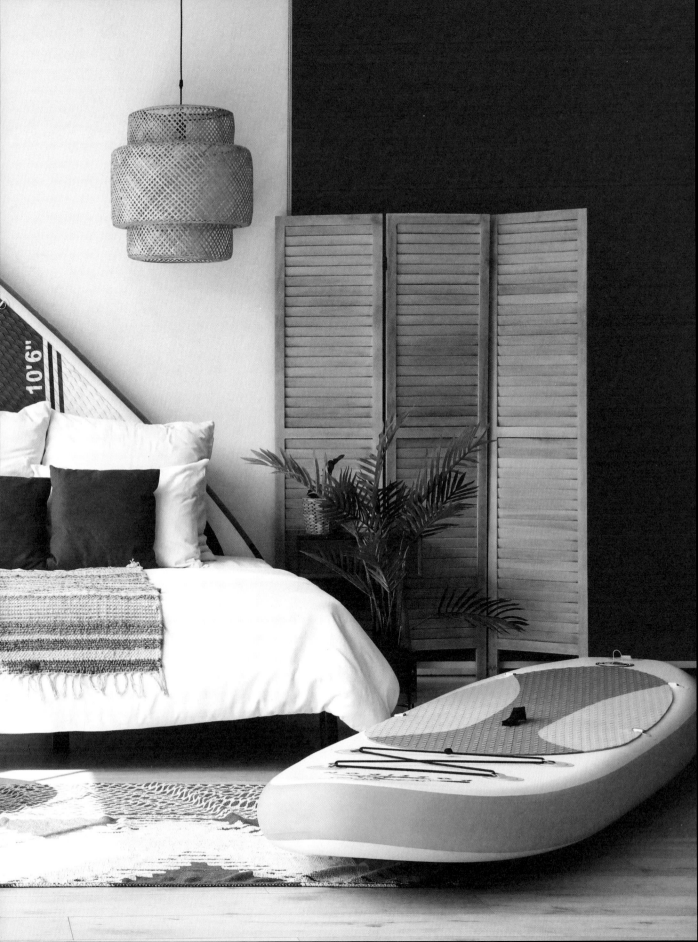

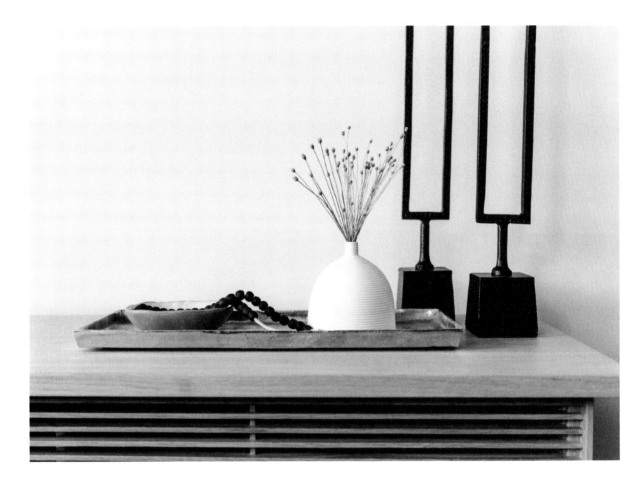

Grouping an assortment of unfussy objects is an artful way to display your favourite wares. Rotate the items as your collection ebbs and flows like the sea.

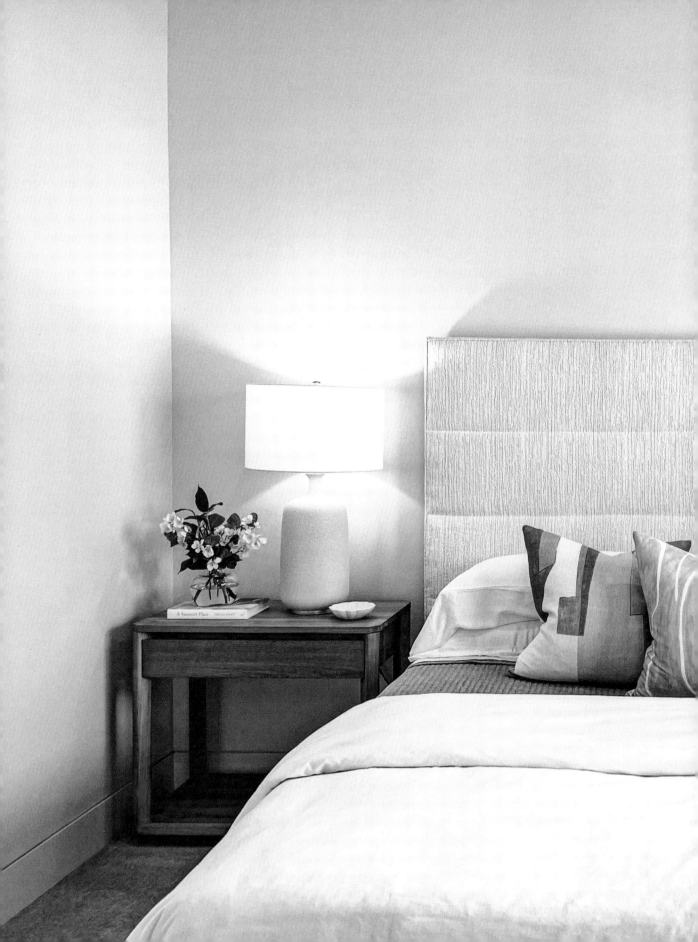

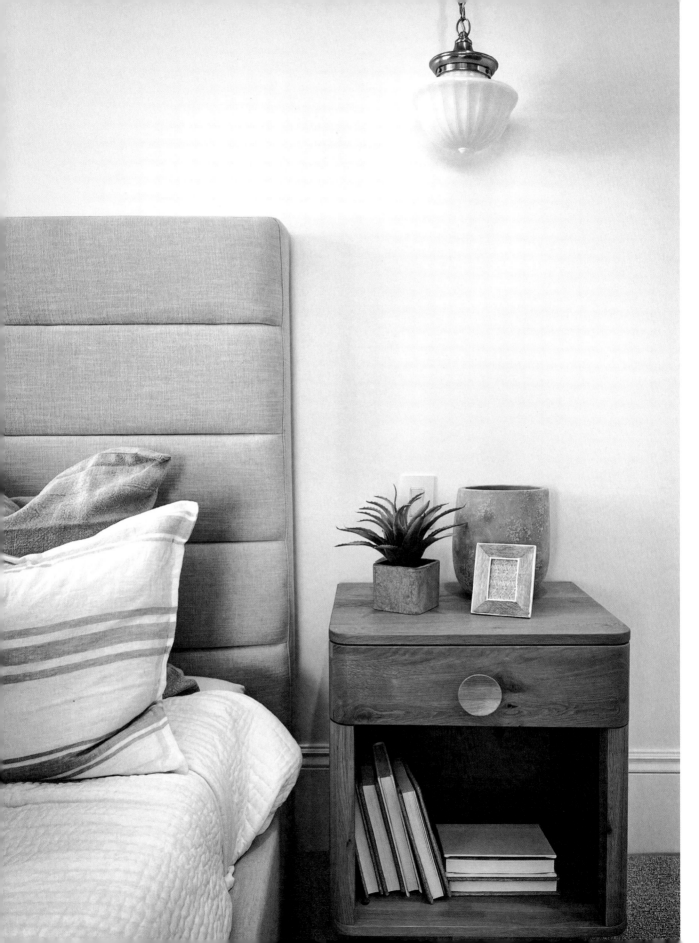

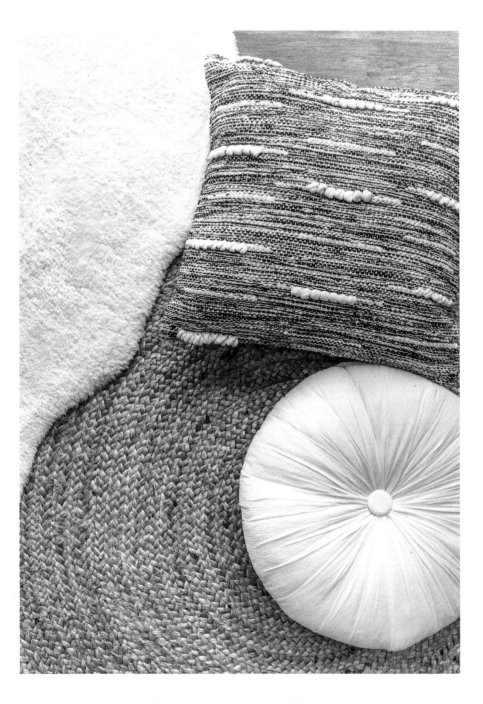

Combining soft furnishings made from different materials with smooth, rough and raised textures can uplift and bring interest to the room.

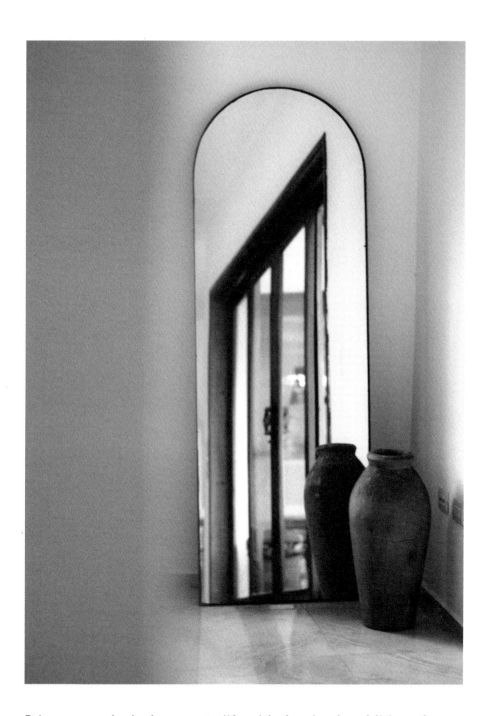

Bring an overlooked corner to life with the simple addition of a small arched mirror and a piece of vintage earthenware sourced from an antique store or market.

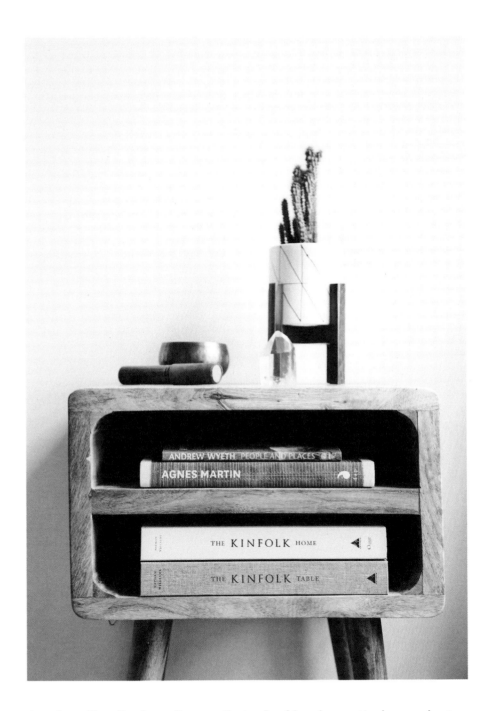

An altar-like display of a small stack of books, potted succulent, crystal and other cherished objects brings some personal style to a bedside table.

Complementary fabrics and a muted colour palette are always in vogue.

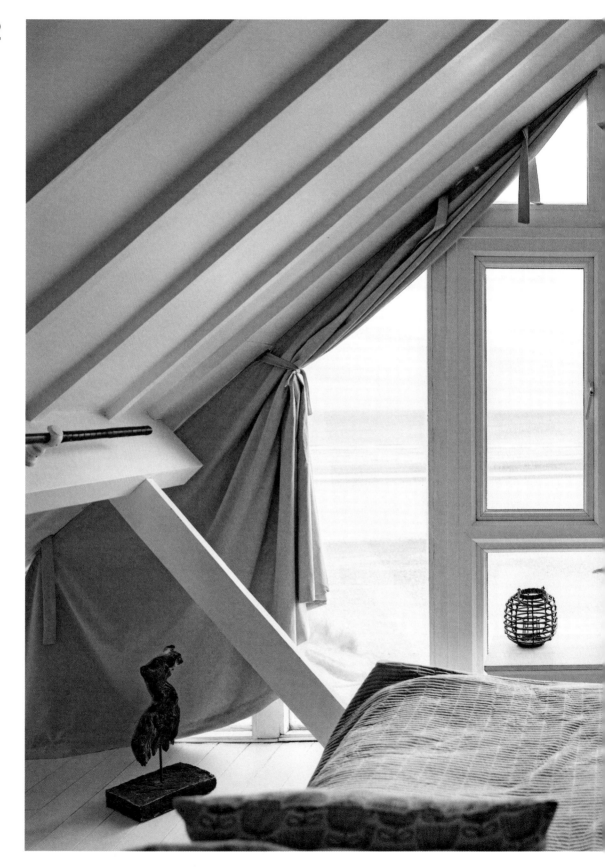

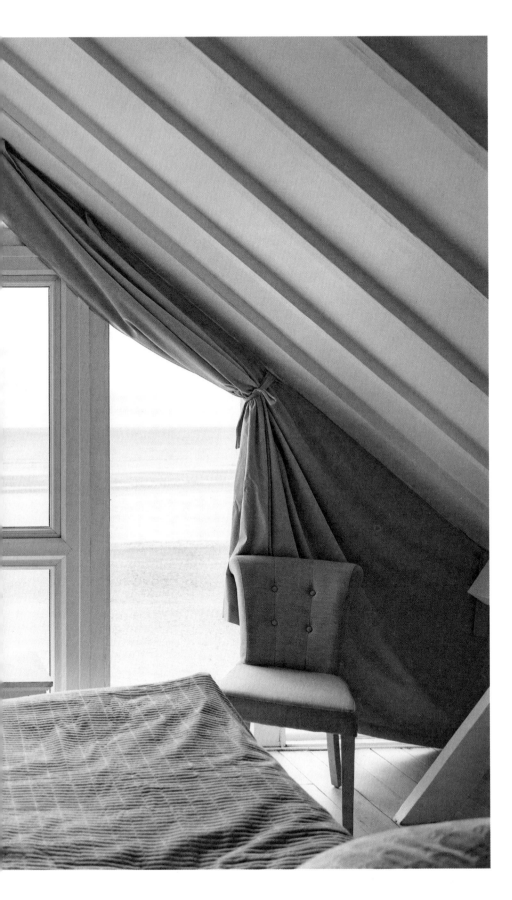

Subdued, earthy hues of blush-pink, salt and sand produce a soothing effect, suiting a beach house sanctuary.

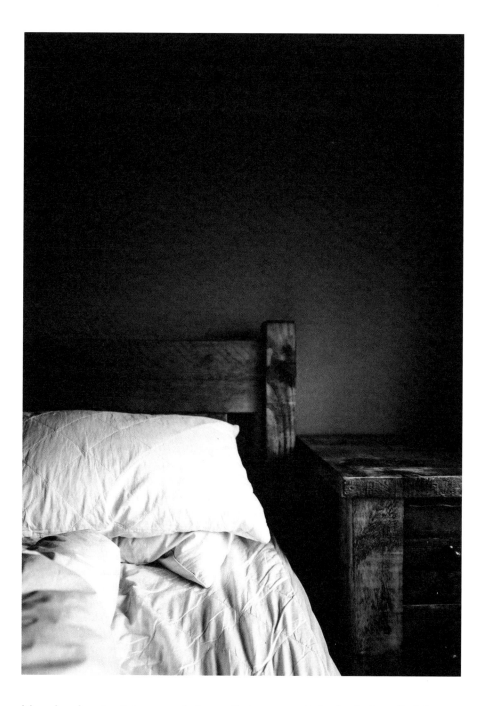

Moody chestnut tones, vintage fixtures and dark timber finishes are ideally suited to an austere, cold-climate beach house on a remote, windswept coastline.

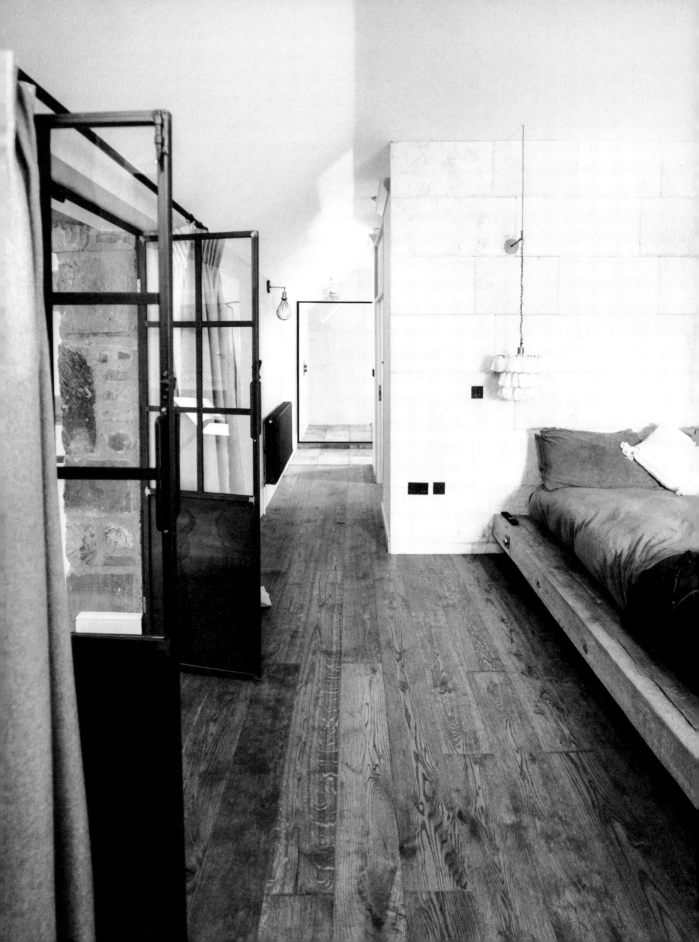

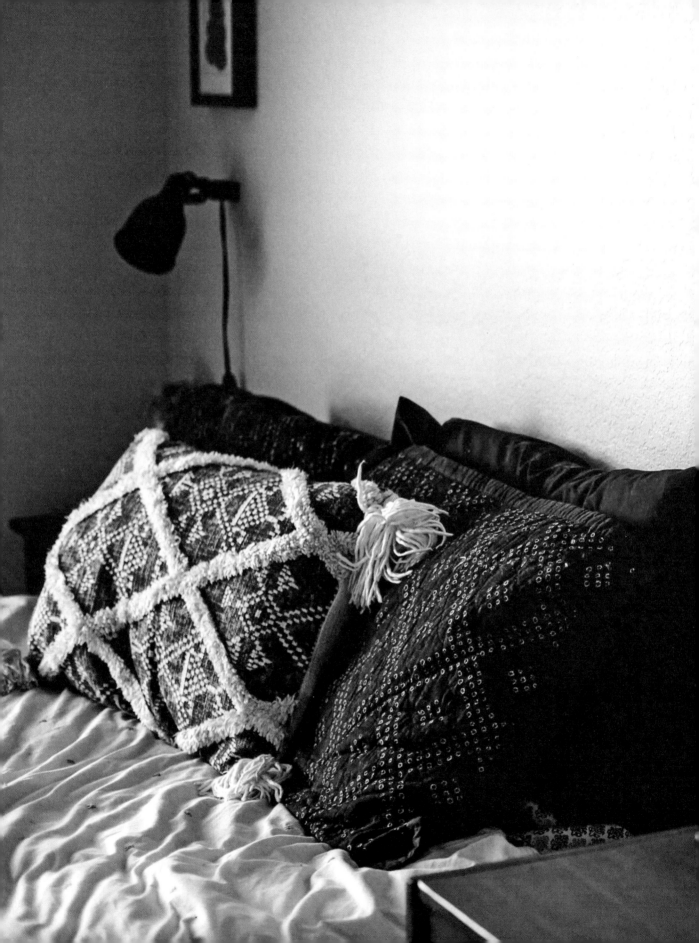

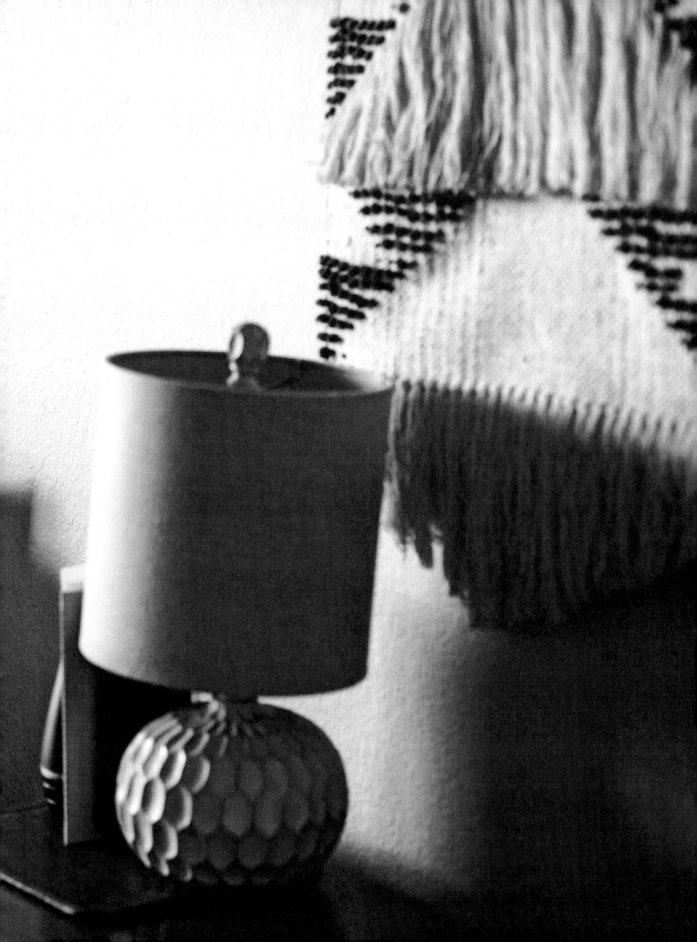

In wintertime, a beach house is a comforting shelter from the elements.

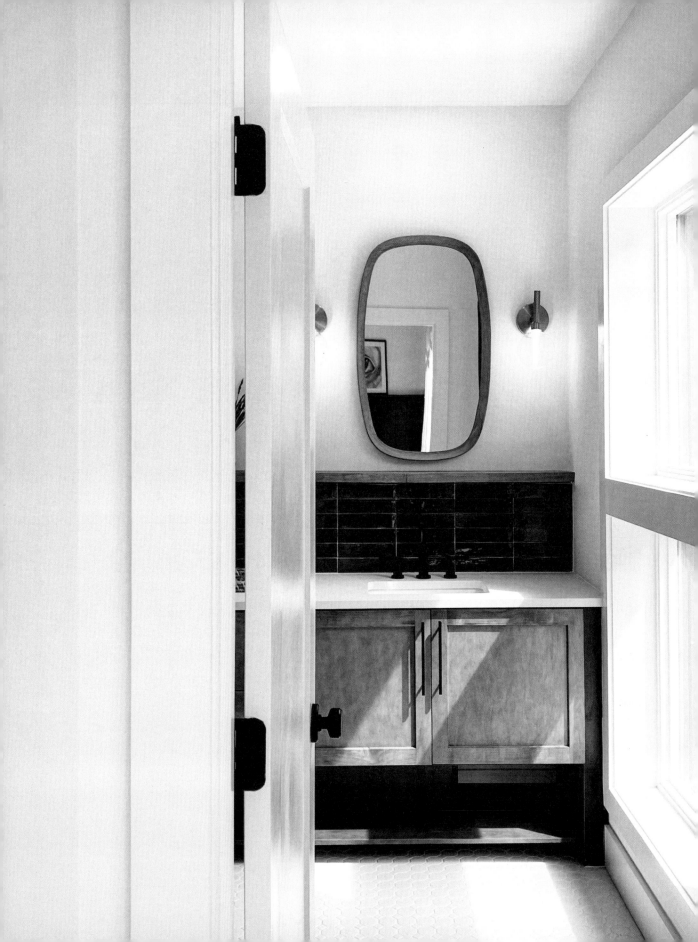

the bathroom

No beach house is complete without a luxurious bathroom to reinvigorate yourself after a day spent chasing the sun, surfing the swell or taking a windswept walk to the local lighthouse. Nothing beats the feeling of having a shower after a dip in the sea, or soaking in a freestanding bathtub filled with warm water and botanical bath oils on a brisk autumn night. From reclaimed vintage tapware to porthole-shaped statement mirrors, there are many ways to bring some nautical character to your beach house bathroom – embrace the charms of living by the sea and let your imagination guide you.

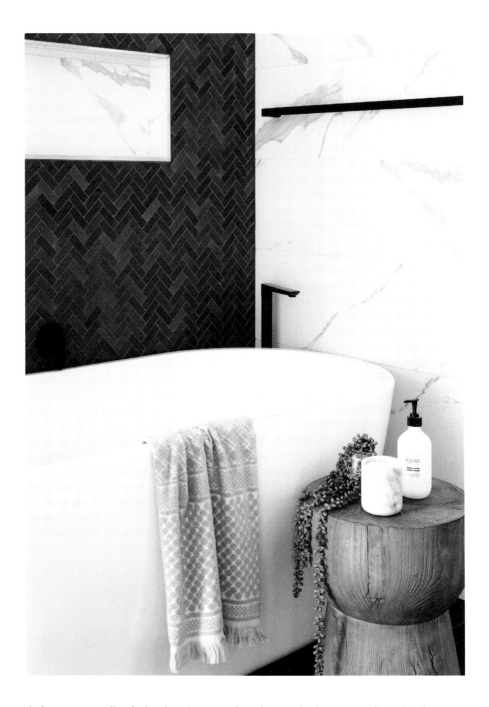

A feature wall of sleek, charcoal-coloured chevron tiles sits in contrast to the natural beauty of the marble tiles and occasional table, handcrafted from timber.

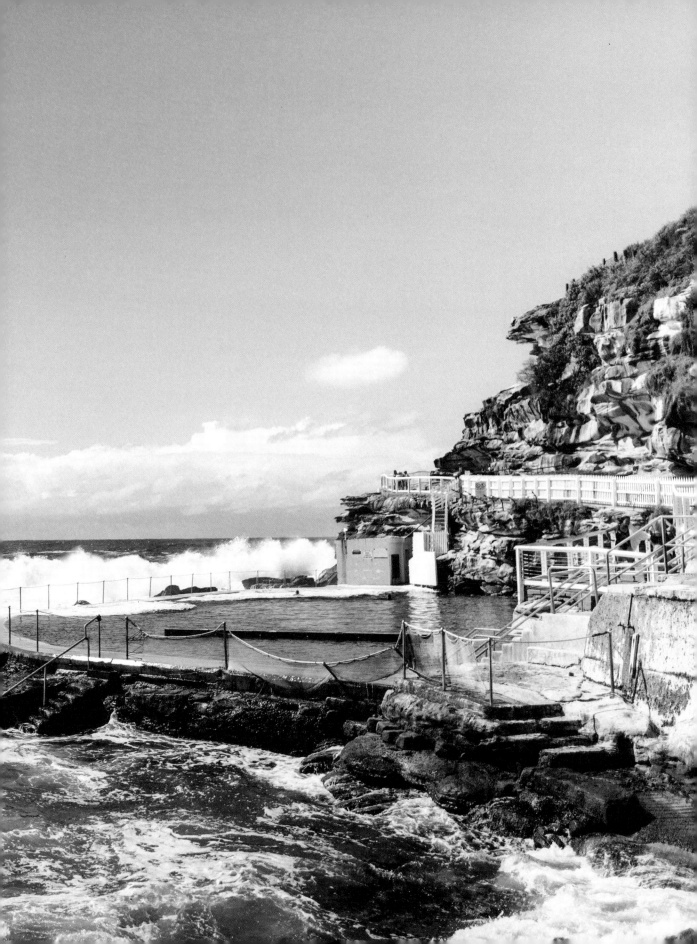

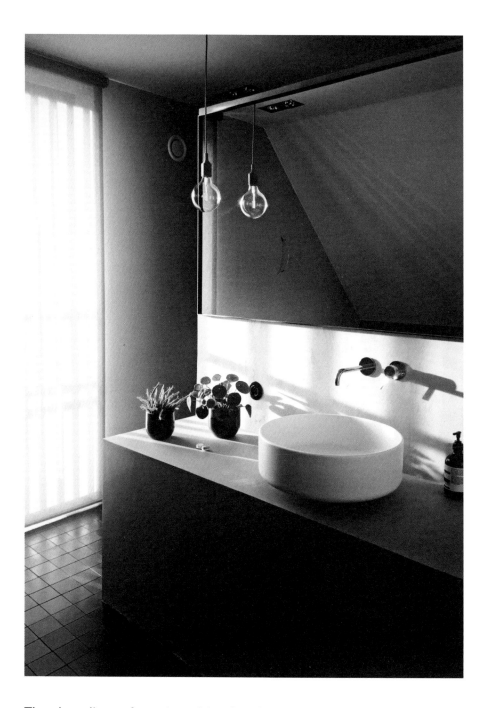

The clean lines of a stripped-back, minimalist bathroom create a modern look perfect for purifying bathing rituals.

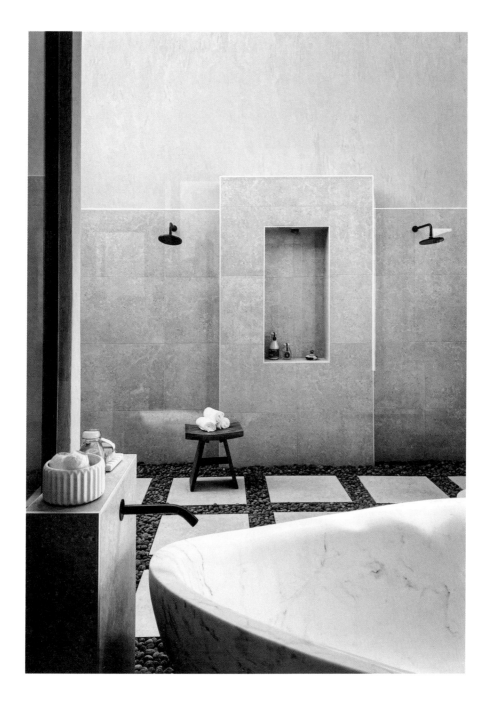

An oversized marble tub, inset shelving niche and utilitarian fixtures make for a striking bathroom with a personality all its own.

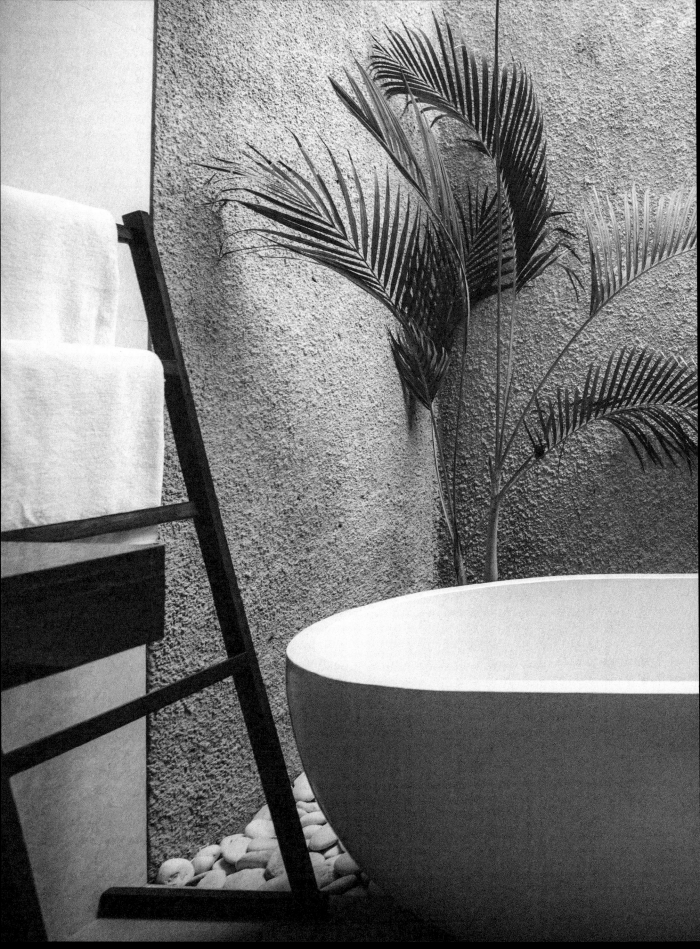

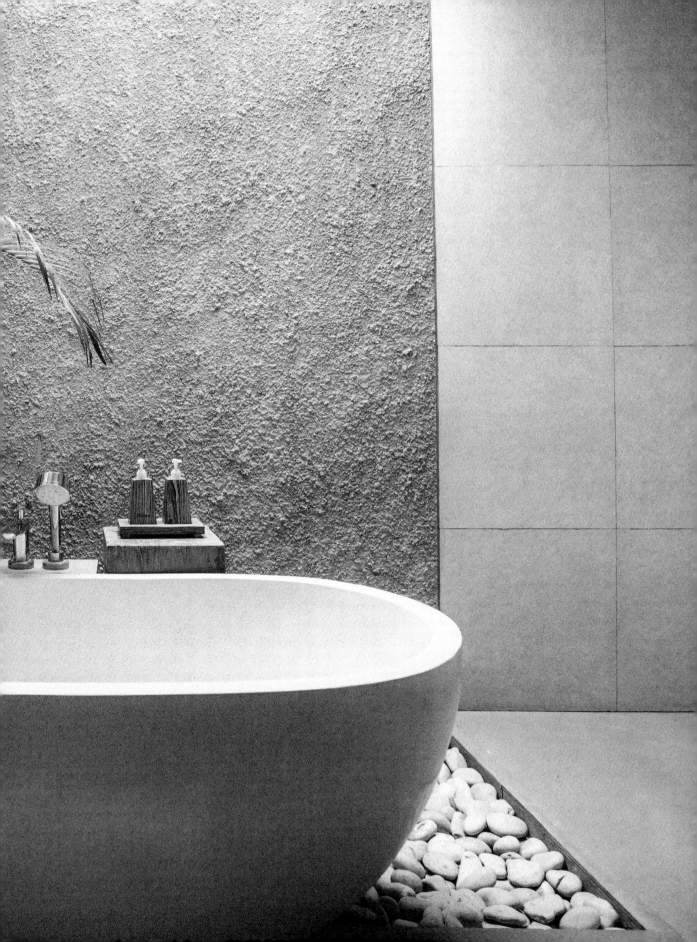

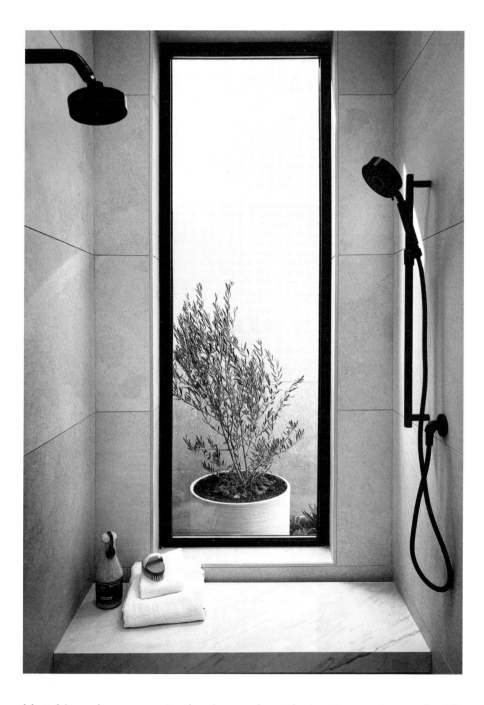

Matching above-counter basins and porthole mirrors, teamed with contemporary lighting that emits a warm glow, is a masterclass in the modern beach house aesthetic.

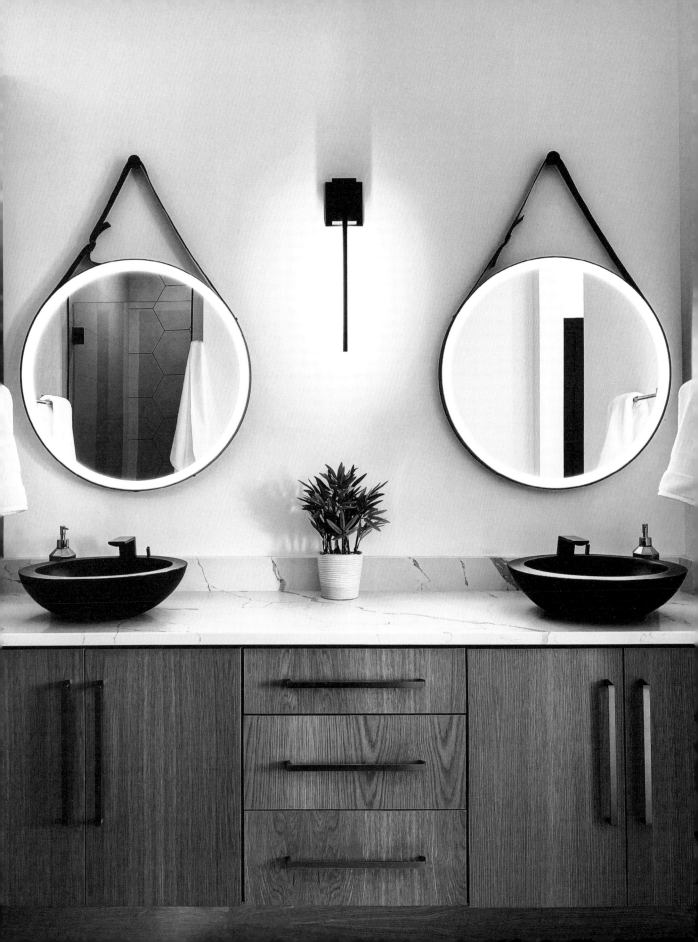

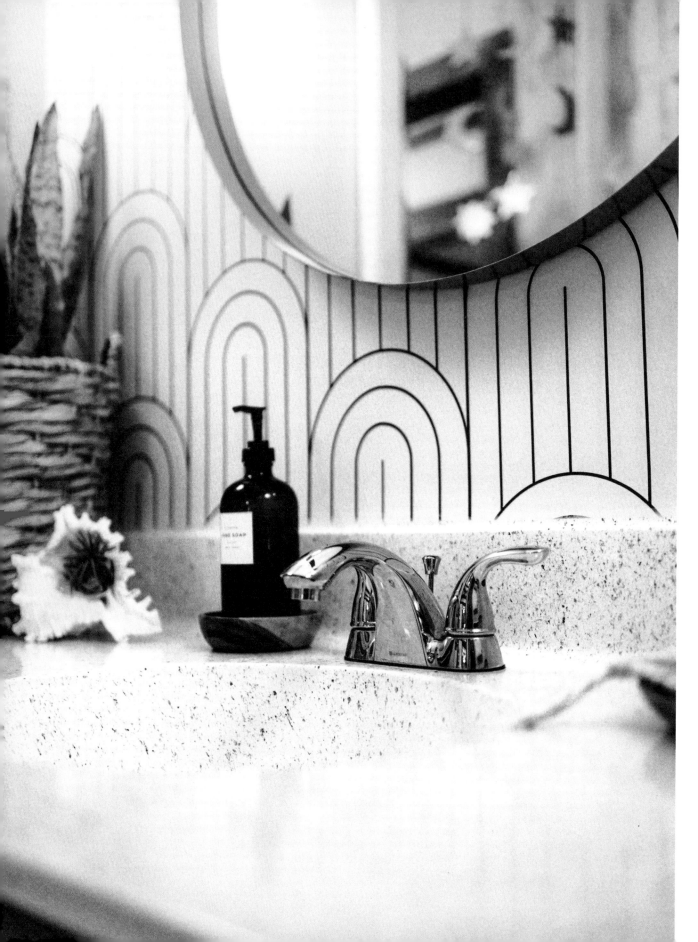

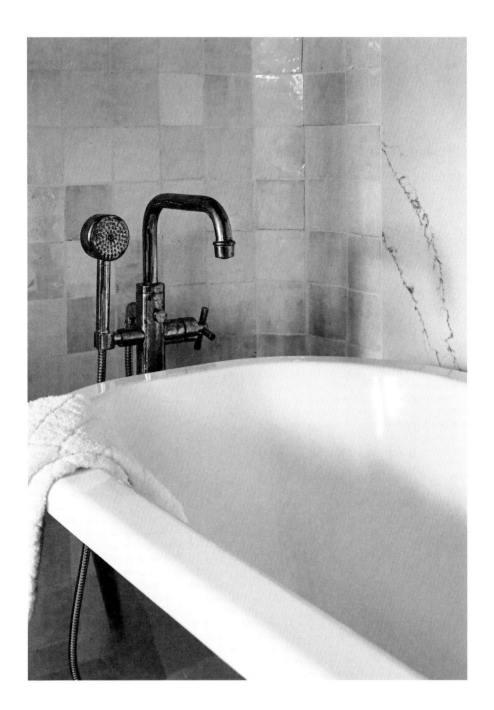

The timeless elegance of brass fixtures attached to a classic clawfoot tub is a nod to the golden age of steamship travel.

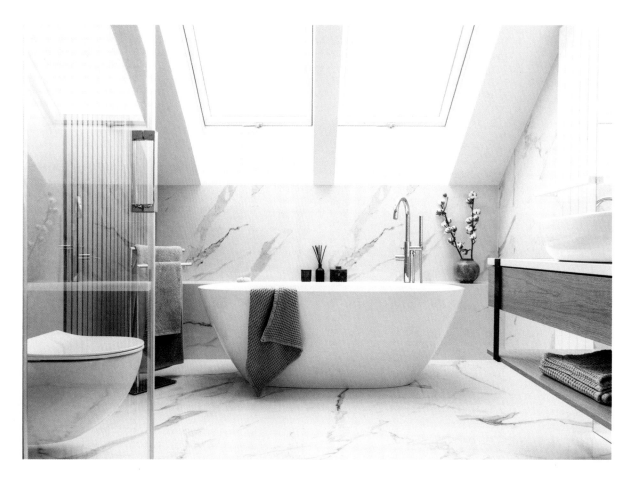

A floating bathtub under large skylights is reminiscent
of days spent in the summer sun.

Circular mirrors with grand, golden frames evoke days aboard opulent cruise liners.

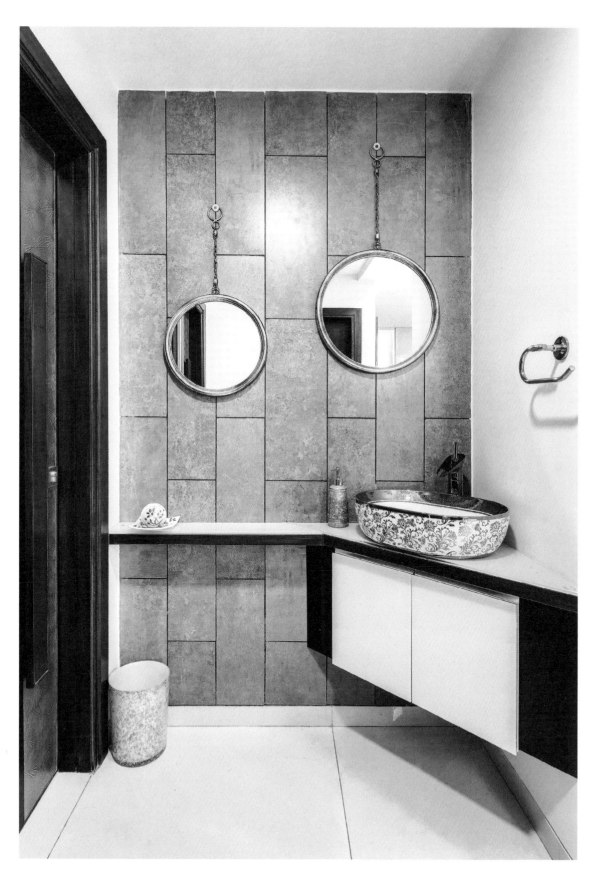

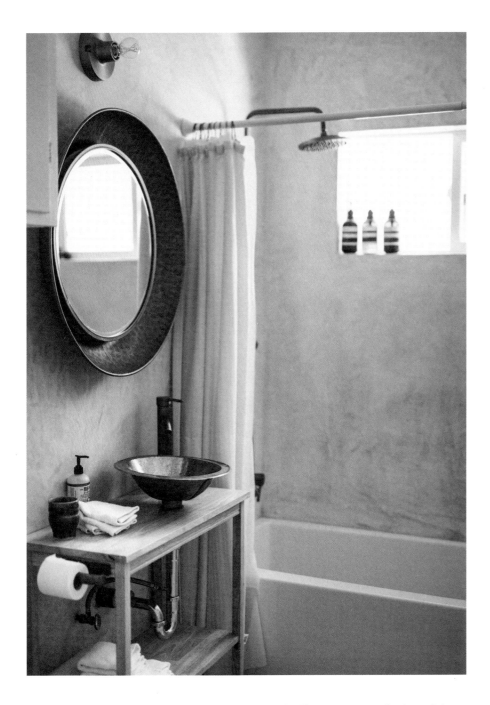

A large, circular, metal-framed mirror similar to a porthole adds some nautical ambiance to the bathroom.

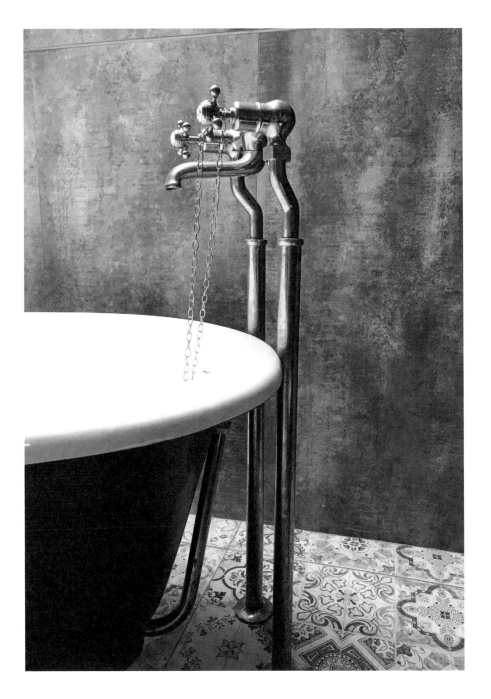

Bring a sense of grandeur to your bathroom with exquisite, vintage-style brass tapware, which harks back to another era while remaining functional.

the bathroom

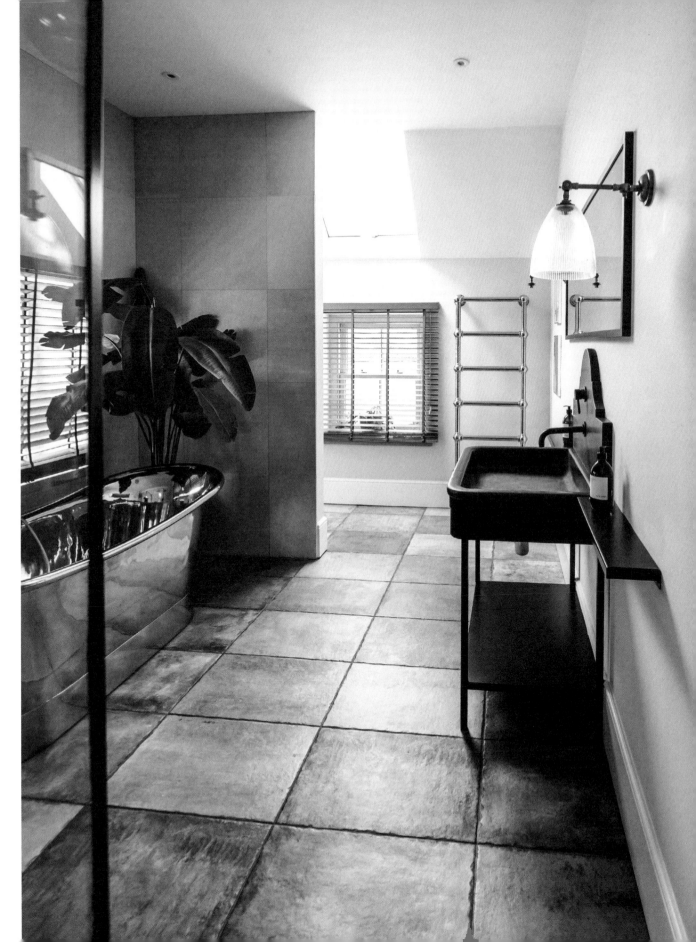

Combining smooth and coarse textures with oceanic tones recreates the feeling of wading into a tidal pool.

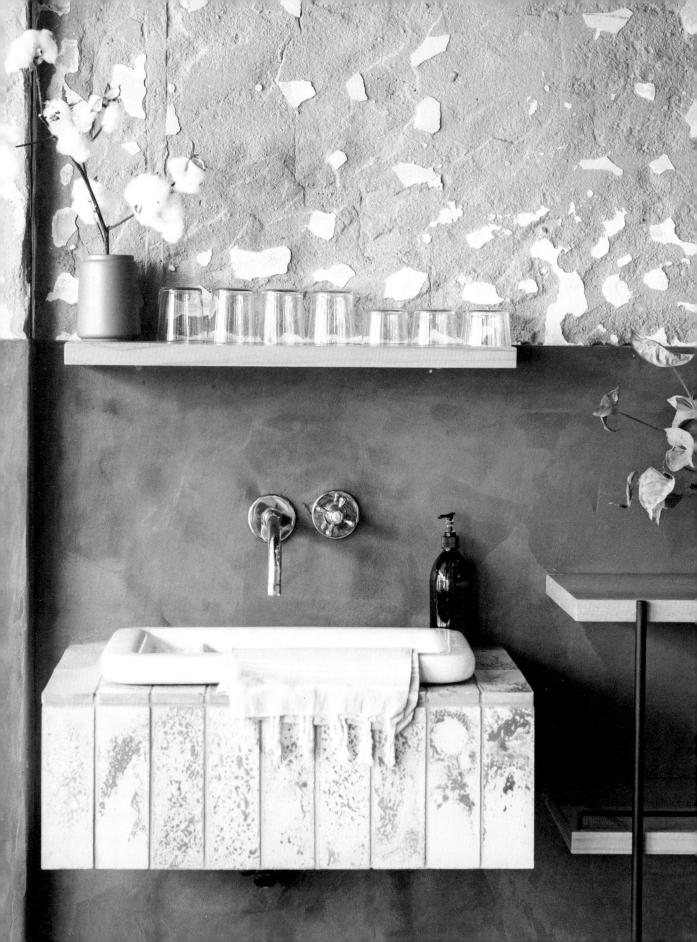

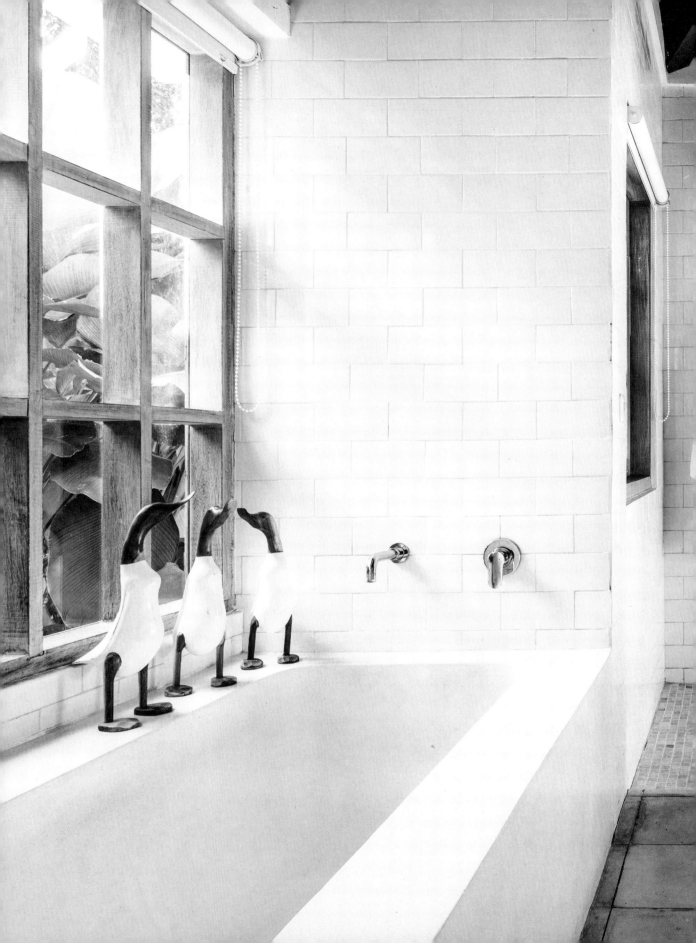

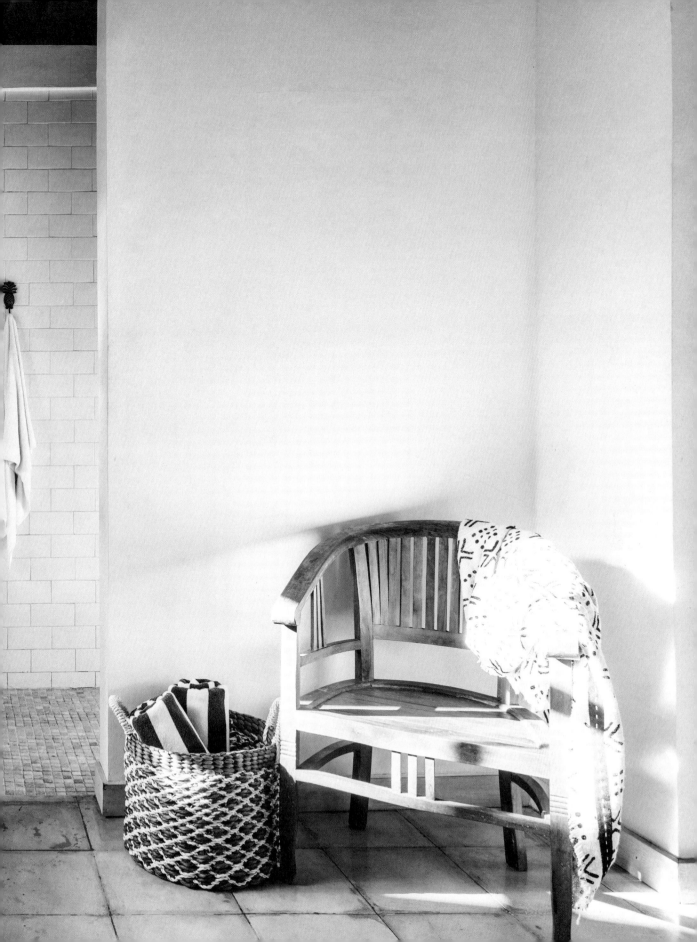

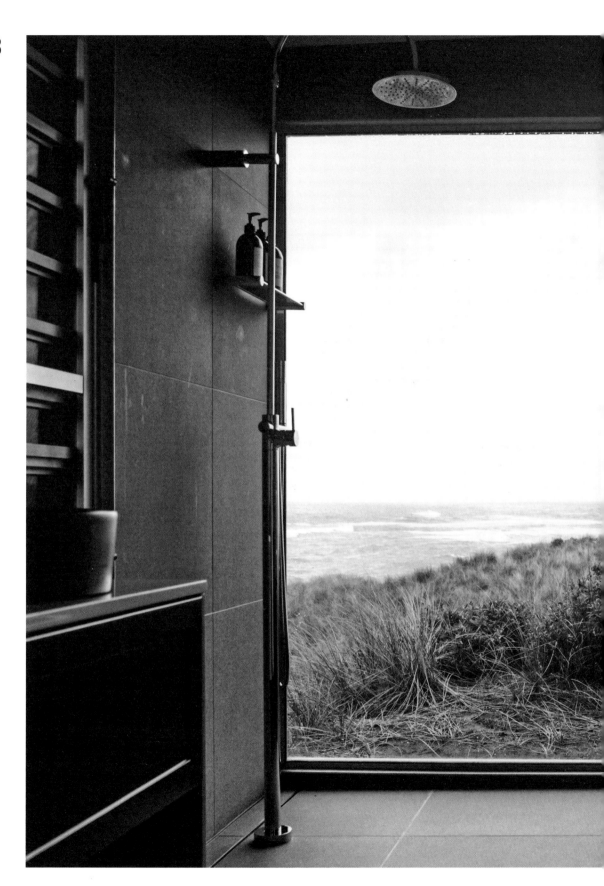

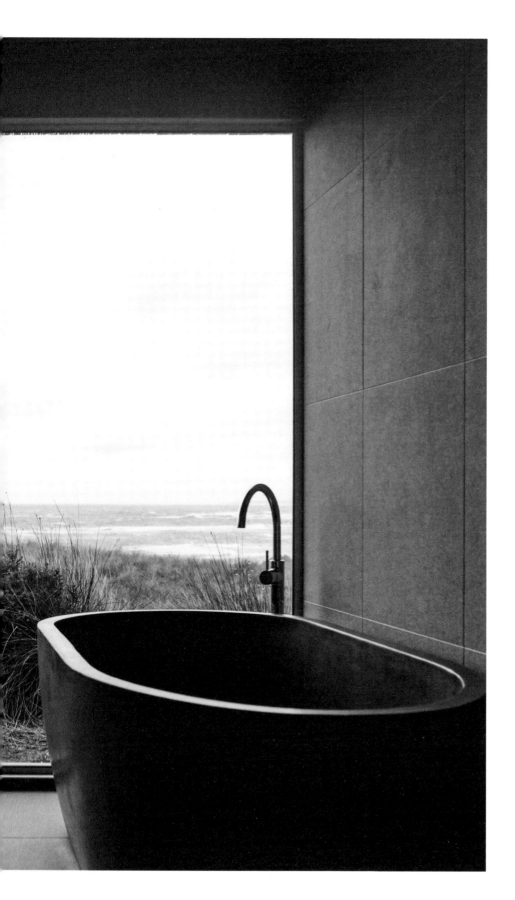

Sometimes all you need is a view to finish off a simple space.

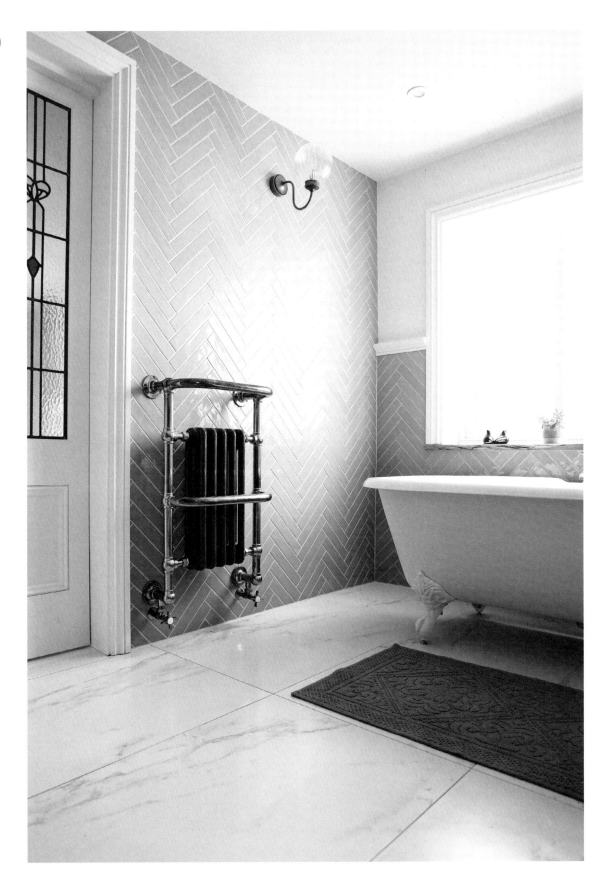

Hints of the sea can be found around every corner.

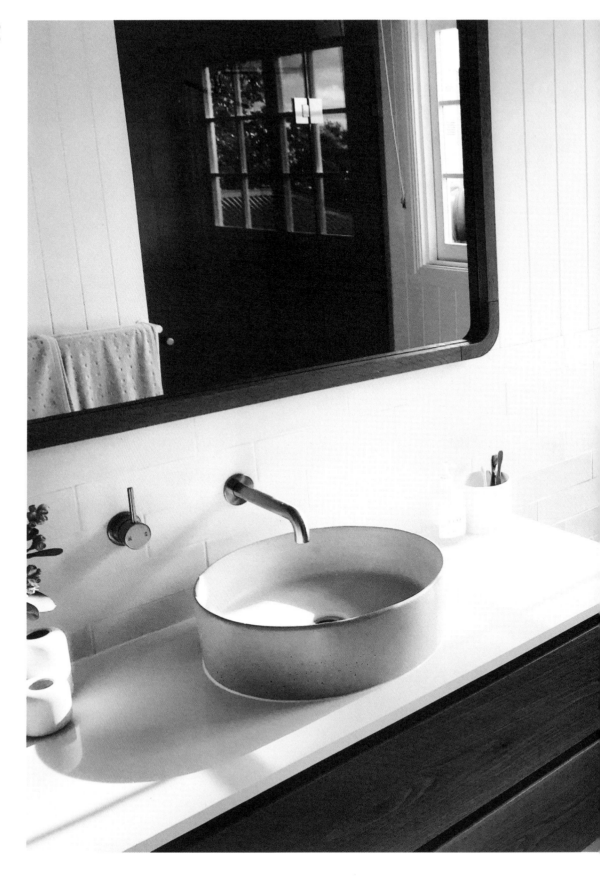

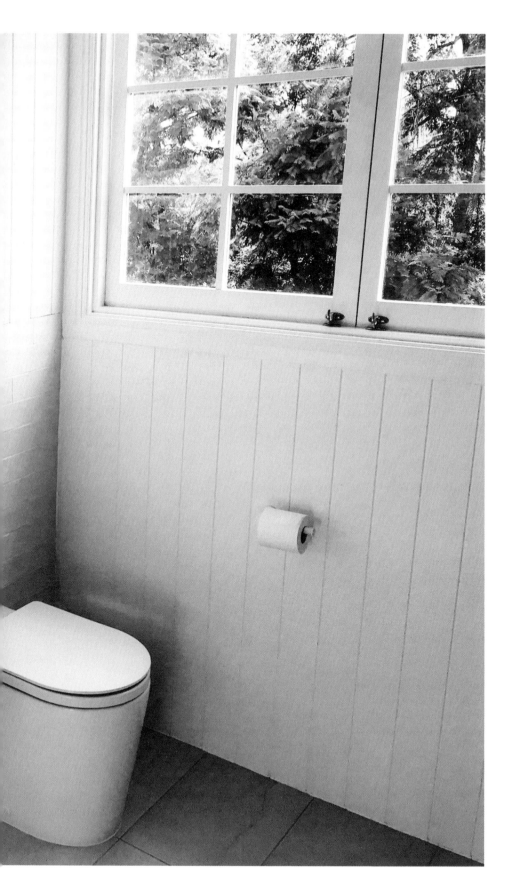

A neutral space is enlivened by adding a dreamy clamshell-pink basin and luxe brushed rose-gold tapware.

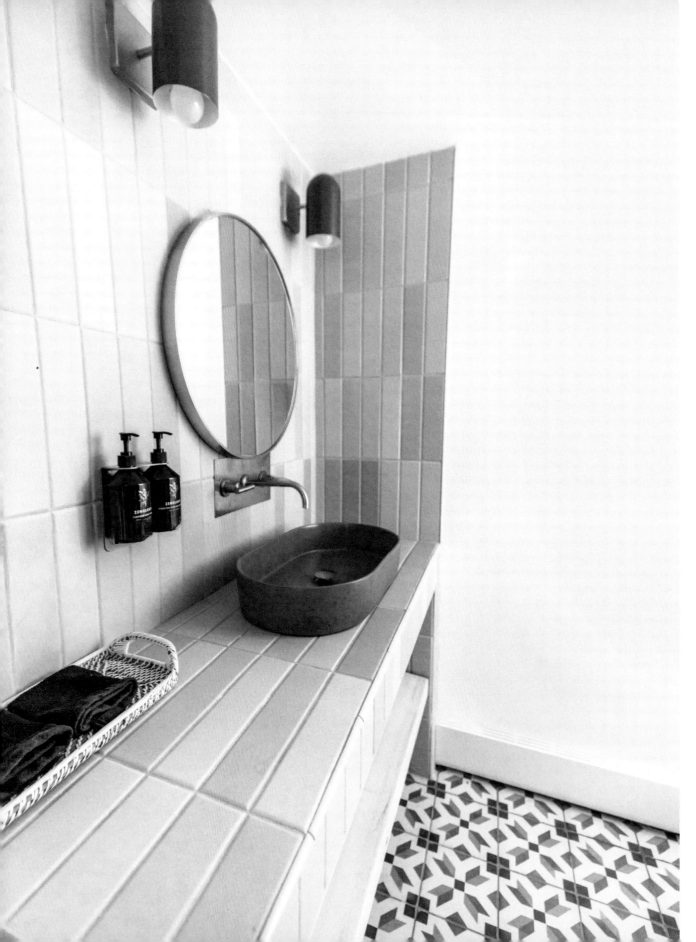

Remember to take inspiration for your bathroom
from even the most surprising places.

No matter the season, a beach house bathroom is a haven all year round.

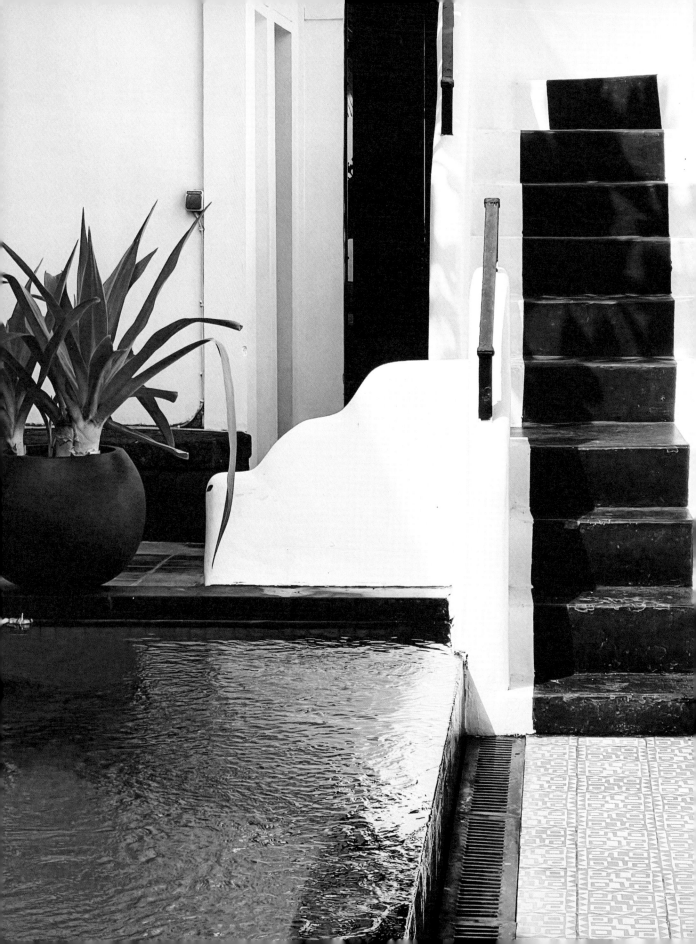

the outdoors

A coffee in the garden as the sun rises, an afternoon spent lazing by the pool with a paperback novel, a barefoot barbecue followed by some stargazing with friends . . . beach house living is about embracing fresh air, birdsong and wide-open spaces. From a rustic courtyard decorated with upcycled feature tiles to a modernist triumph with heavenly resort-style infinity pool, a beach house's outdoor areas are just as important as its interiors. Bring elements of the ocean to your space with calming water features, woven seagrass wall hangings and treasures reclaimed from the sea. While other spaces may be static, let your alfresco areas ebb and flow like the ocean tides.

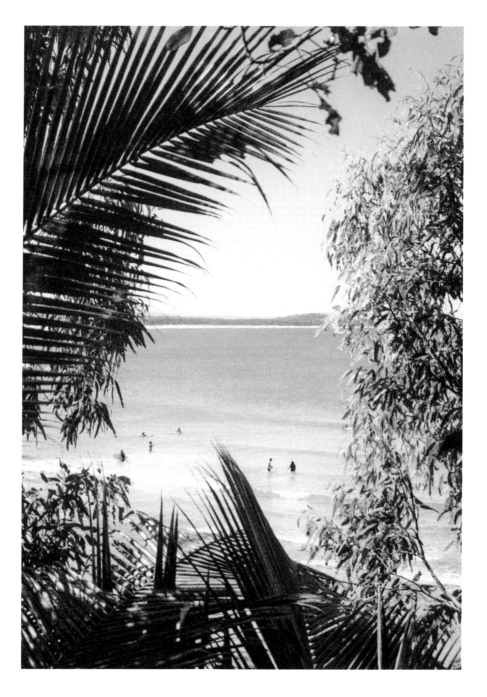

From deep azure tones to bold aquamarines, let your outdoor spaces reflect the colours of the ocean.

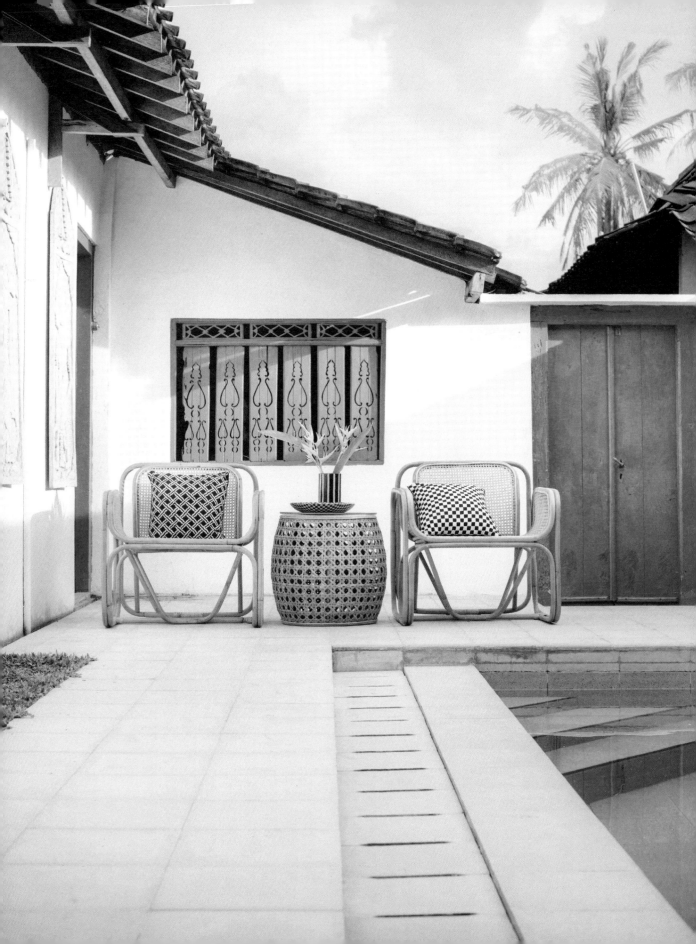

Summon the spirit of the sea to work its magic in your home.

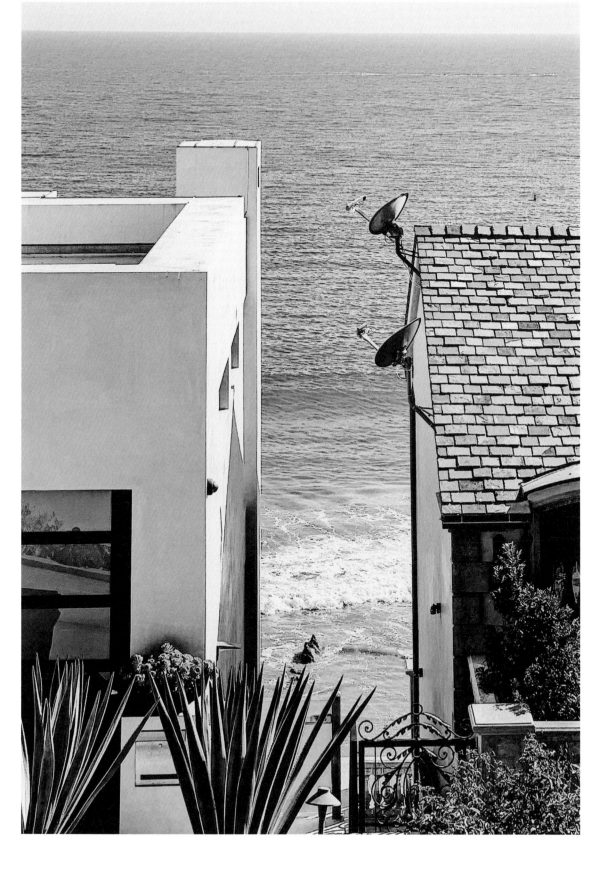

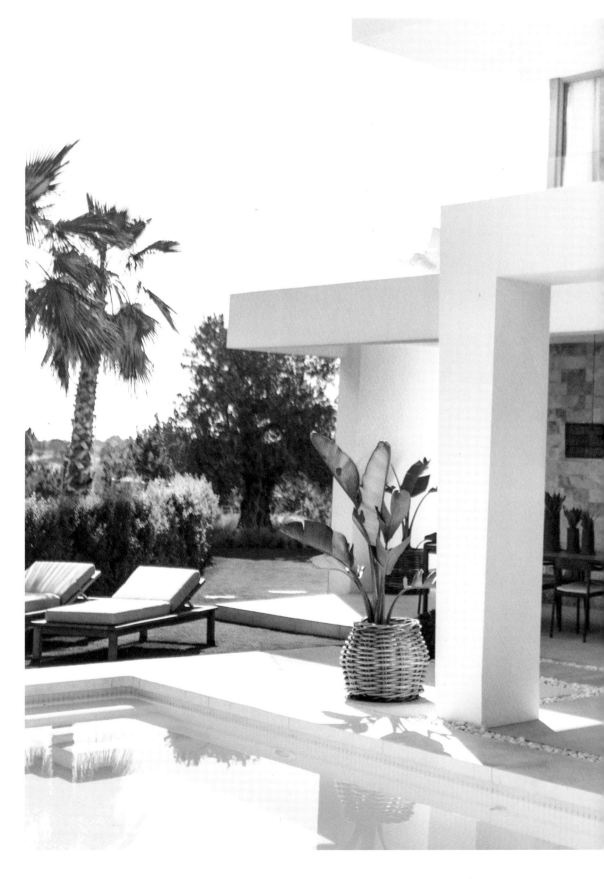

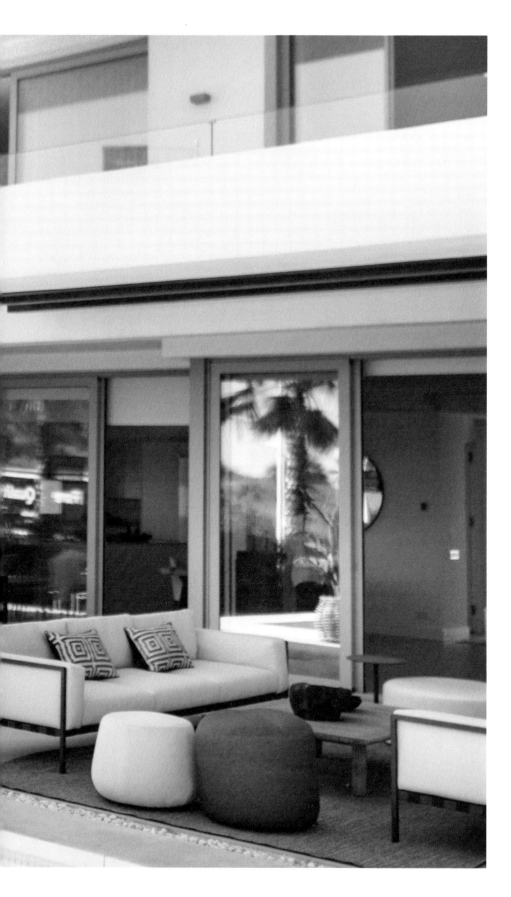

A pop of tropical blue from the pool creates a visual effect where the house almost fades into the background.

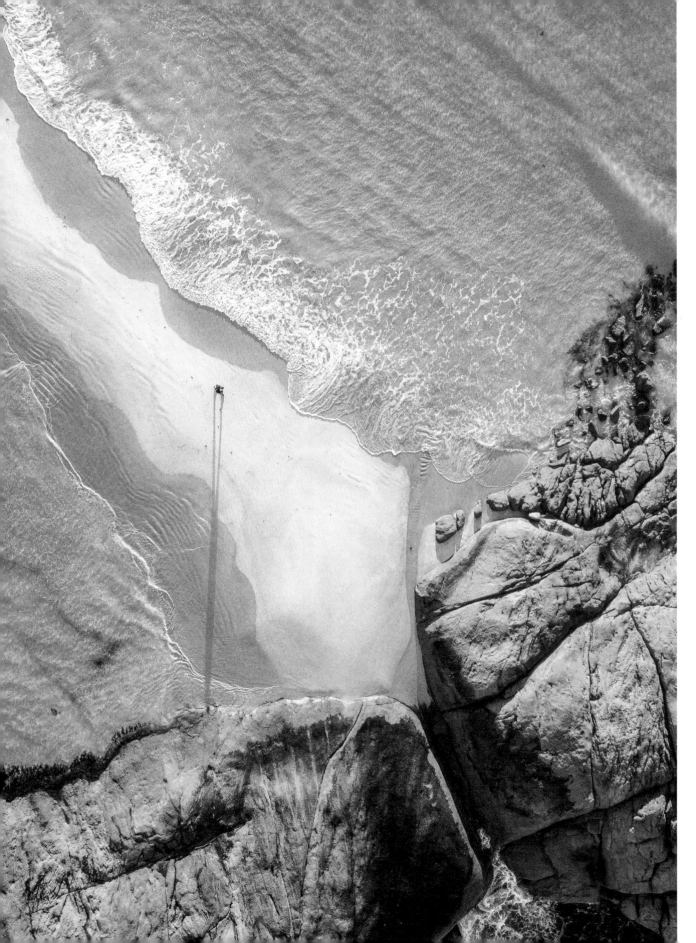

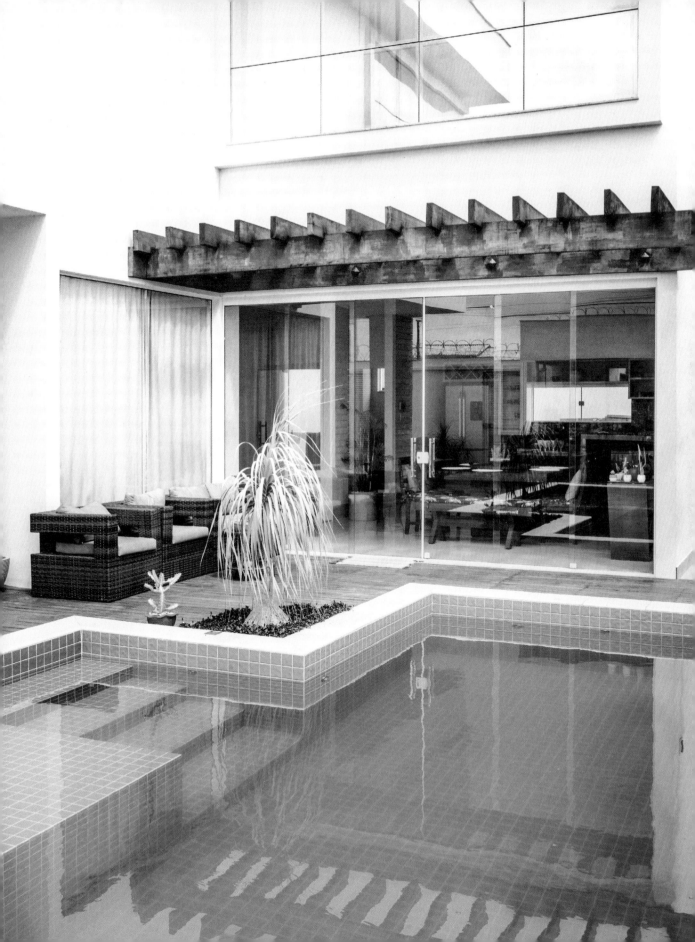

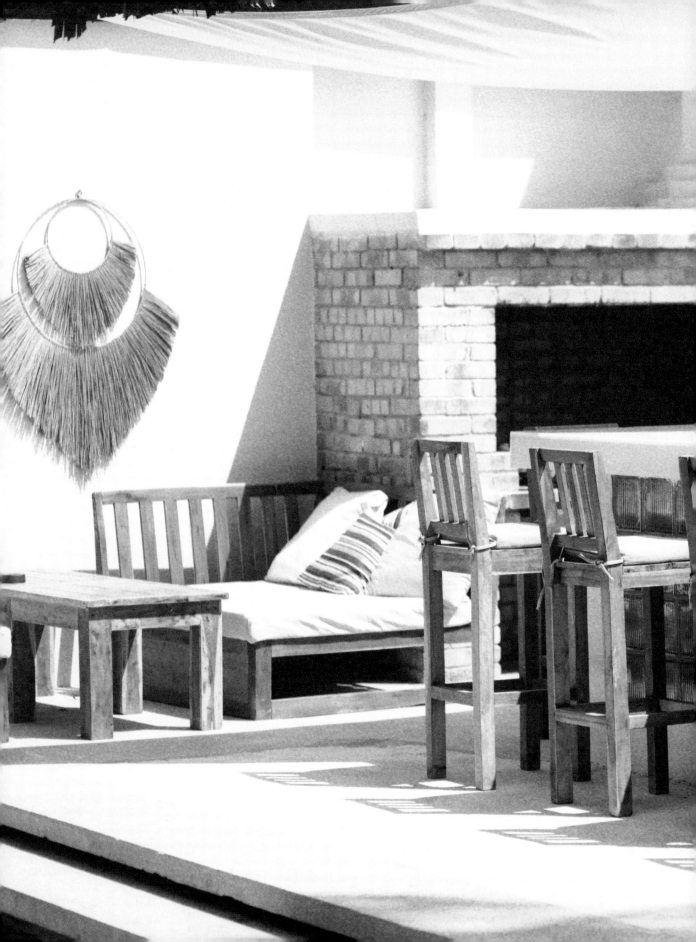

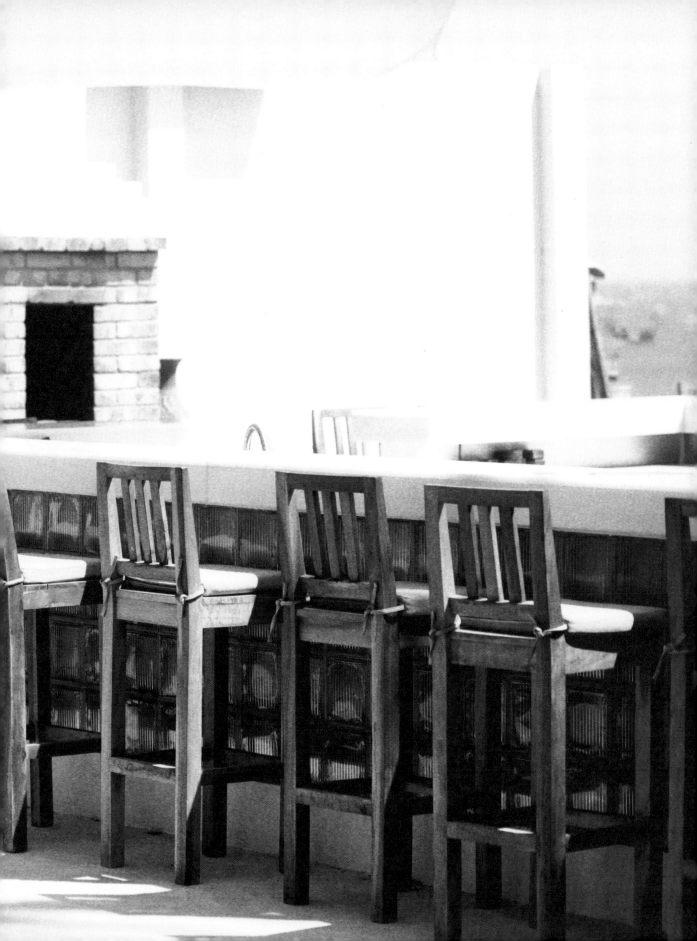

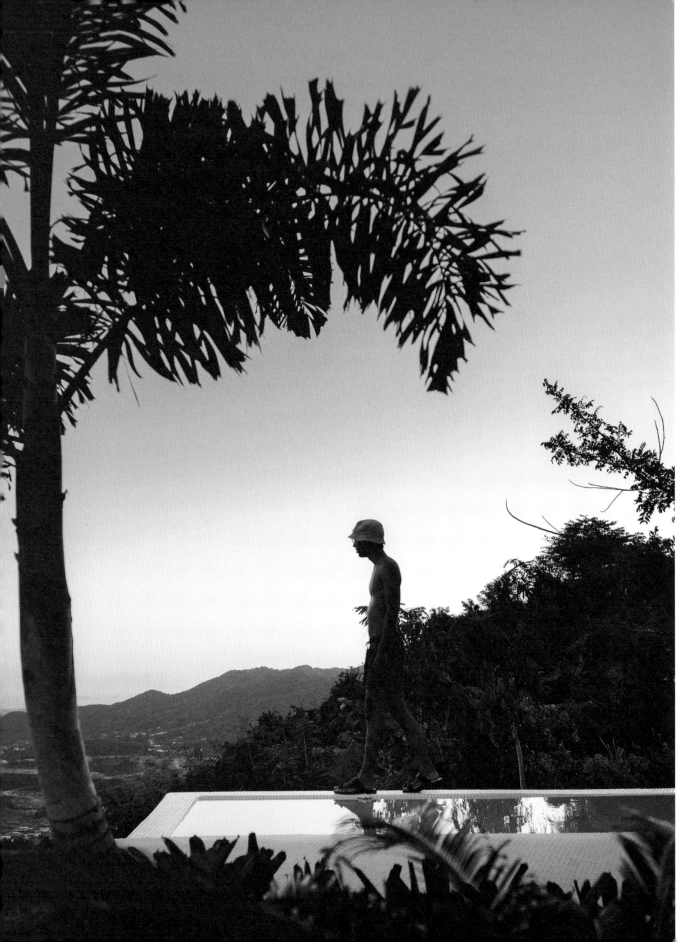

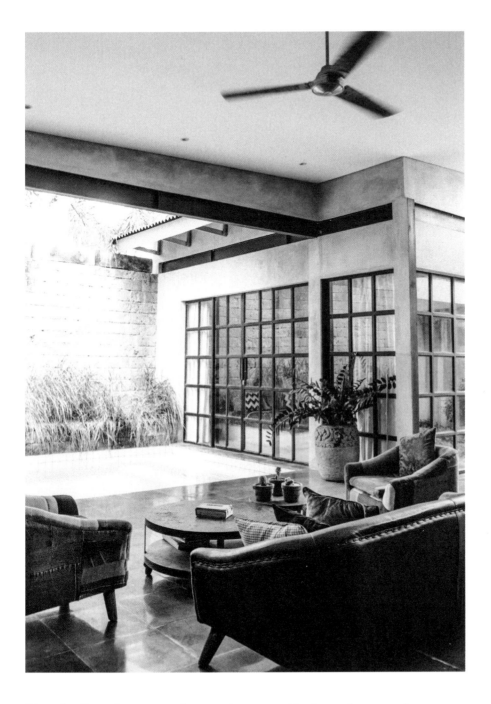

Blur the lines between the outdoors and indoors by creating hybrid, open-air living spaces that make the most of sunshine and sea breezes.

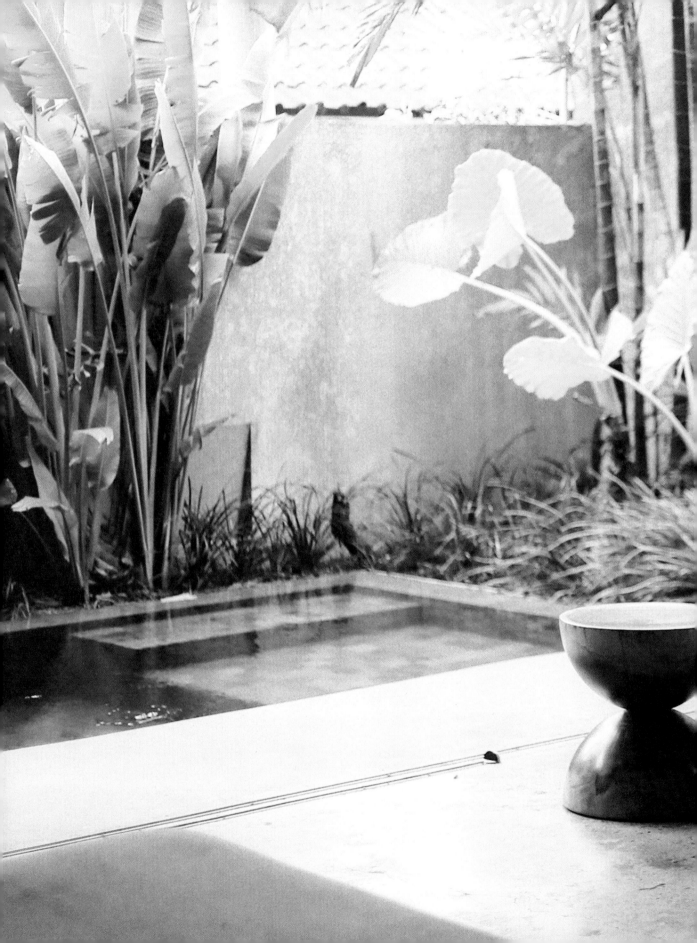

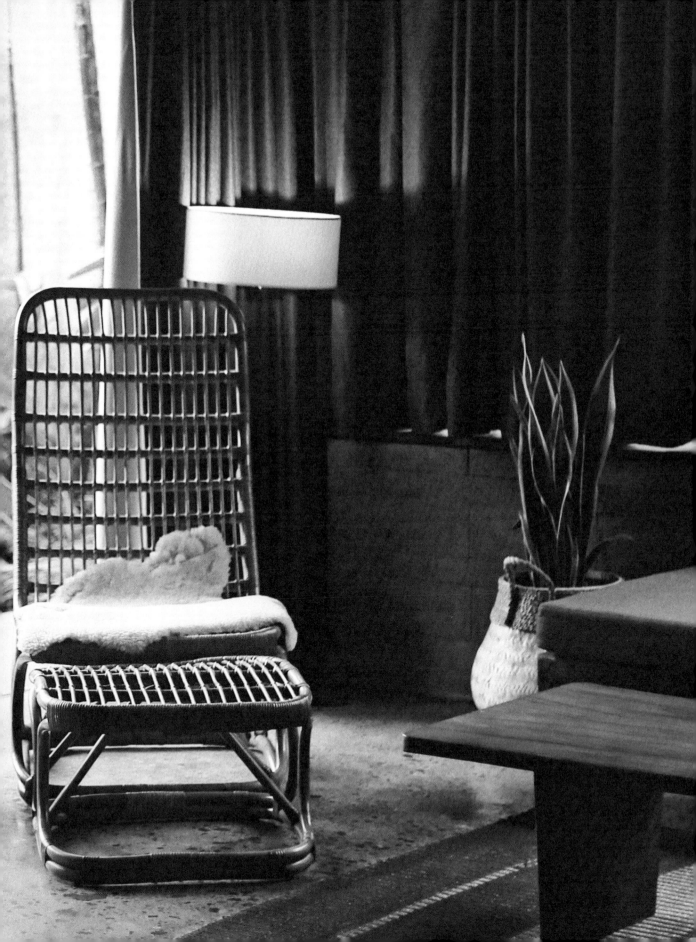

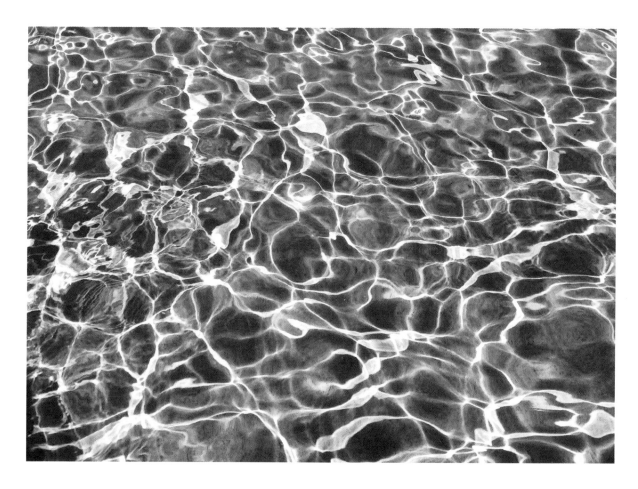

The striking contrast of a black window frame and white wall can be softened by the soothing sea-green hues of a pool below.

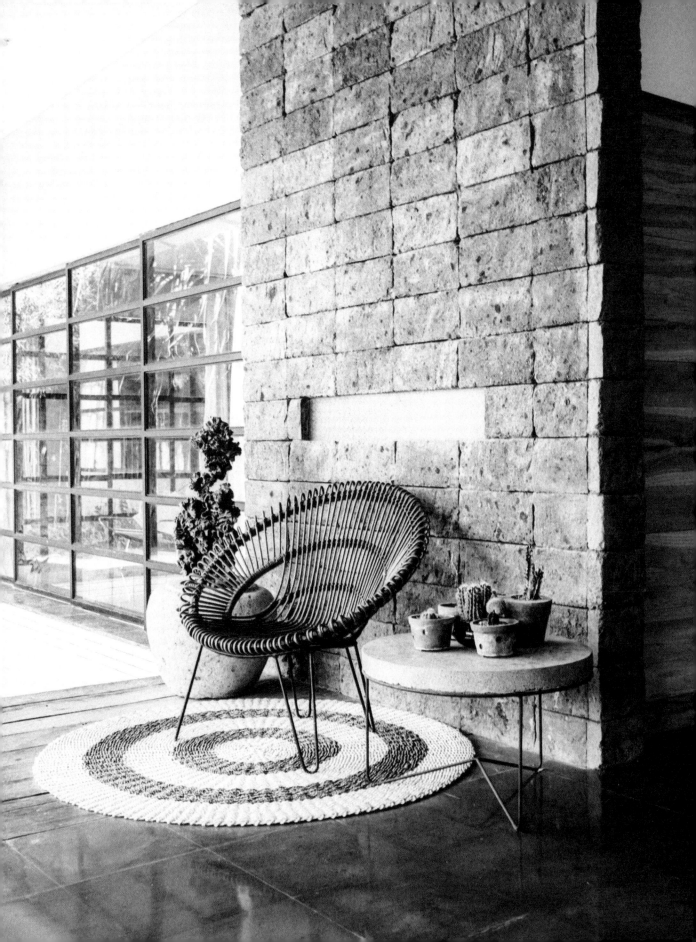

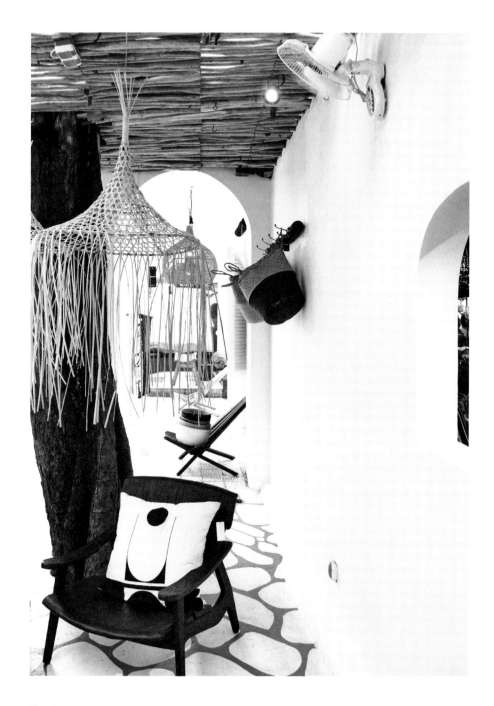

Baskets, lightshades and seating made from natural materials and a roof of rough-hewn timber pay tribute to tropical island living.

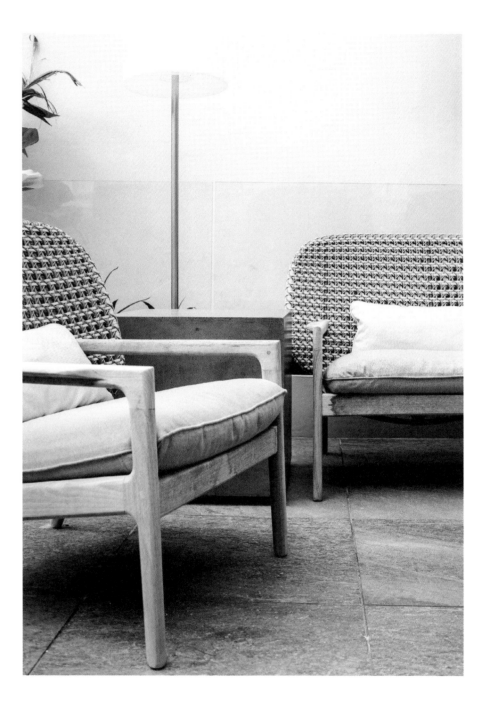

Low-slung, mid-century-style chairs are given a beach house twist with backs made from woven fibres.

Honour the fishing heritage of coastal communities with woven décor.

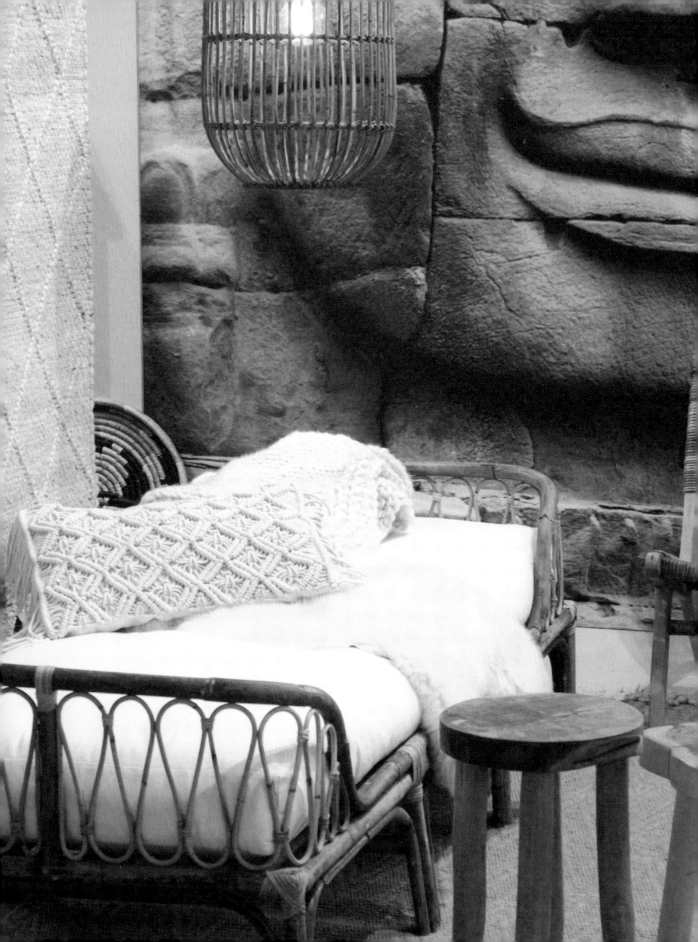

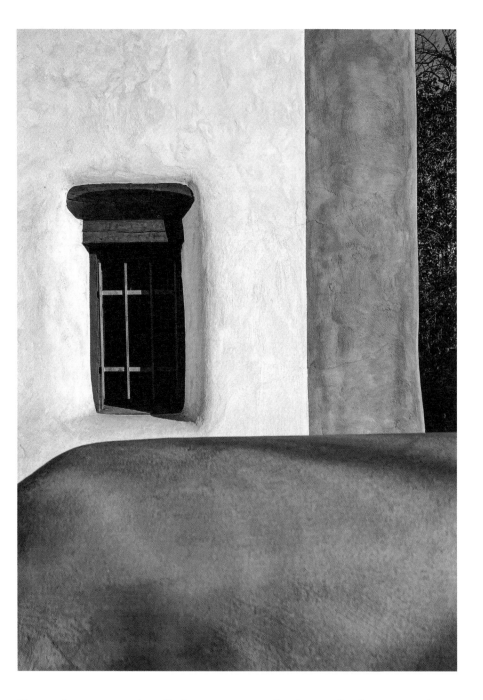

Carved or textured walls in terracotta shades make for an earthy beach house inspired by the dramatic architectural style popularised by Spanish design icon Antoni Gaudí.

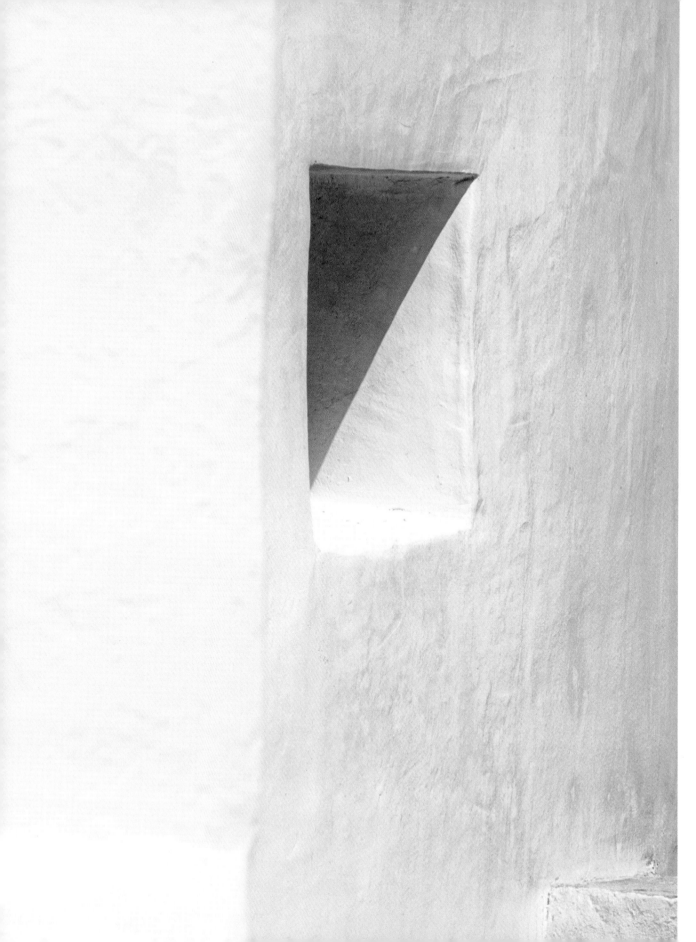

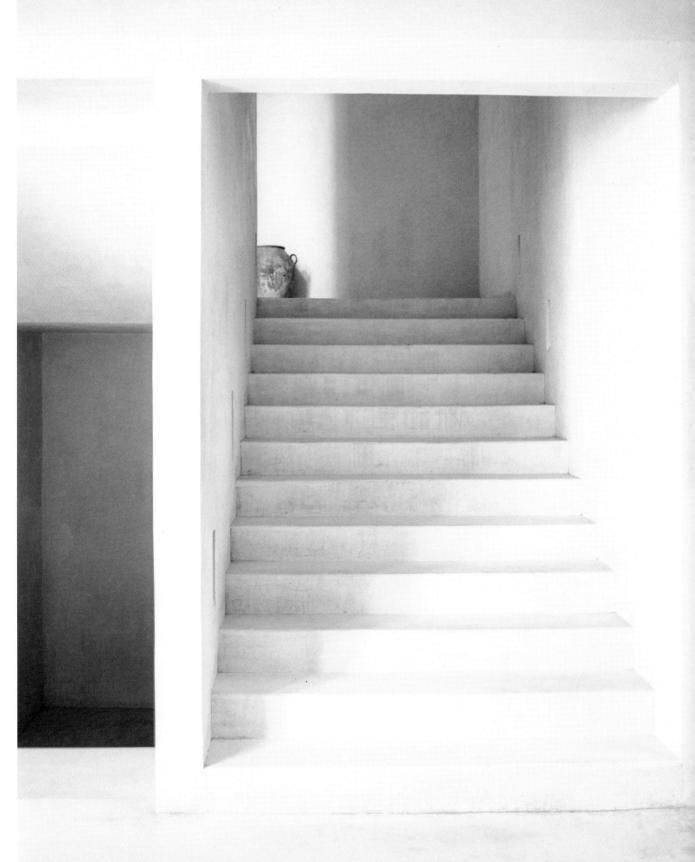

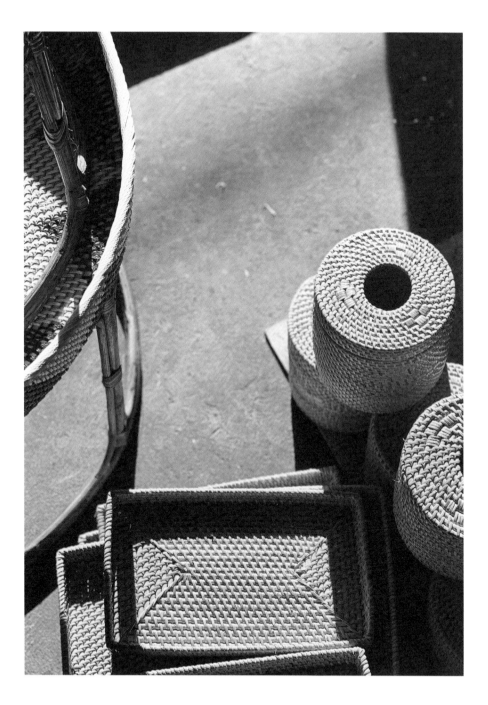

Adding woven baskets and trays is a clever way to bring a natural, organic feel to your outdoor space without making major structural changes.

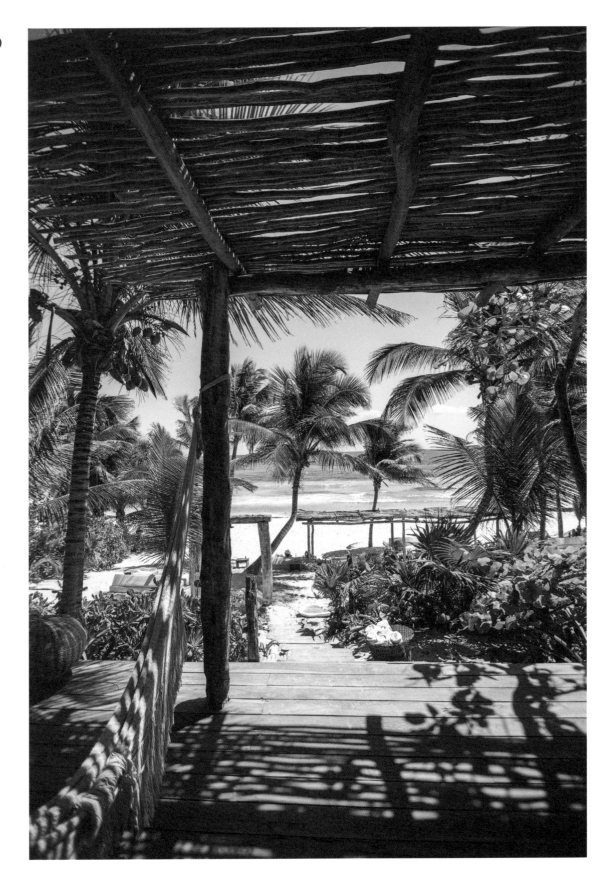

Exposed posts and beams supporting a roof made from undressed, natural timber add character.

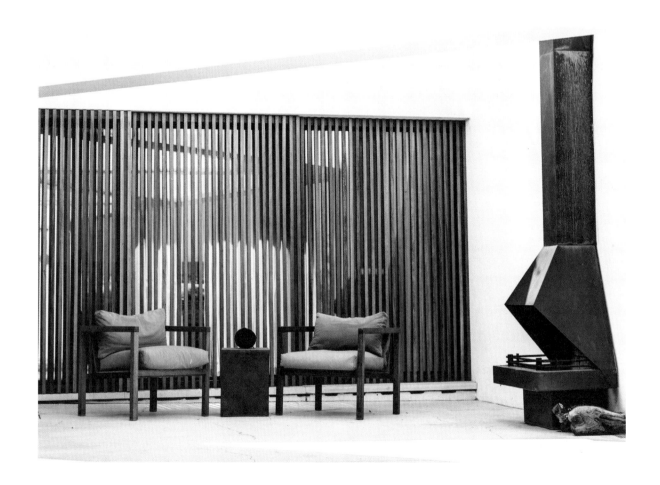

Evenly spaced timber slats reminiscent of a jetty act as a privacy screen but leave enough space for light and air to pass through.

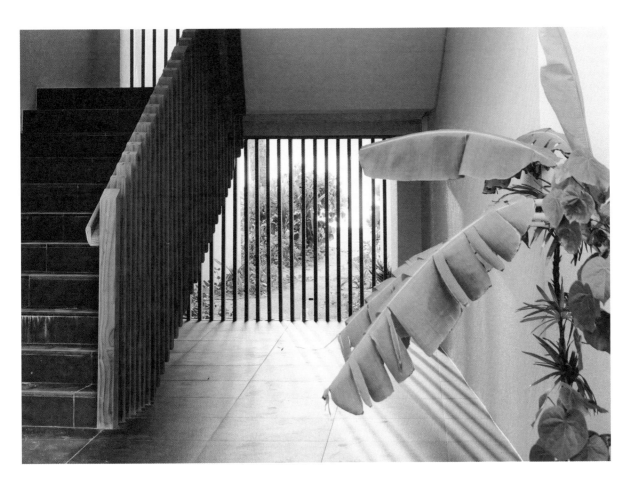

Timber slats bring an organic feel without drawing focus away
from the sublime beach views.

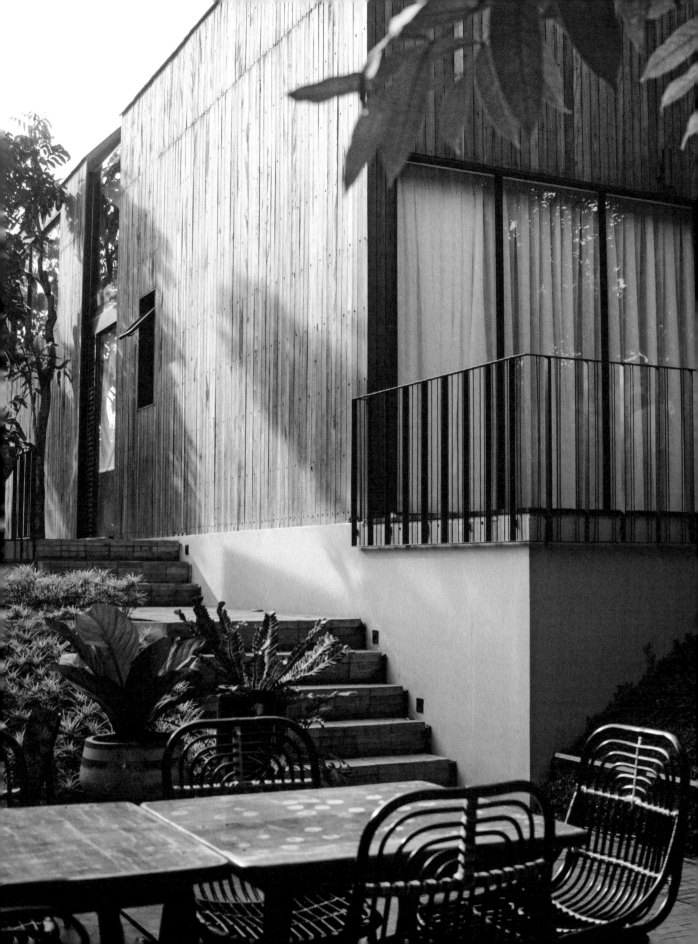

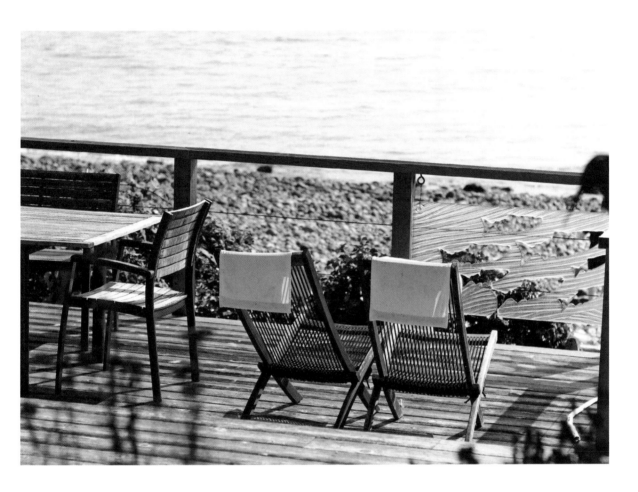

Various forms of seating provide plenty of opportunities to get comfortable while soaking up the fresh air and ocean views.

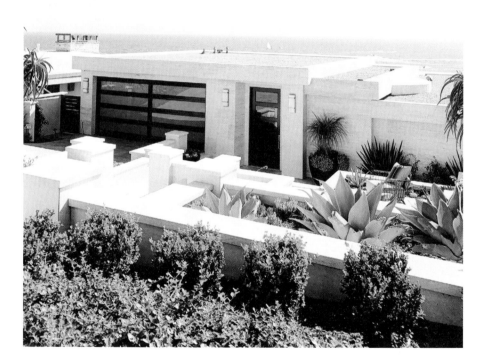

Incorporating irregular shapes into the architecture casts interesting shadows and frames sea views in different ways.

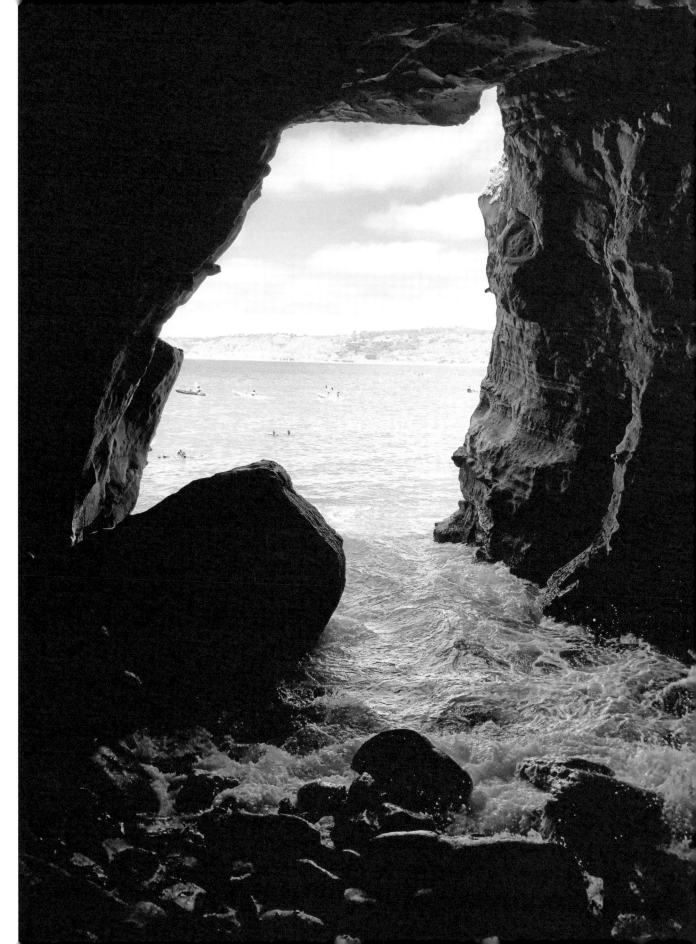

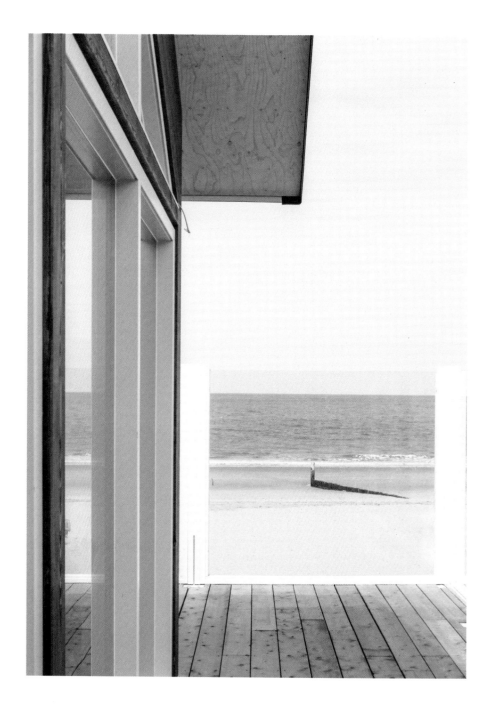

The classic look of a pale timber deck and roof eaves works in tandem with the white sand and hazy sunshine of the beach.

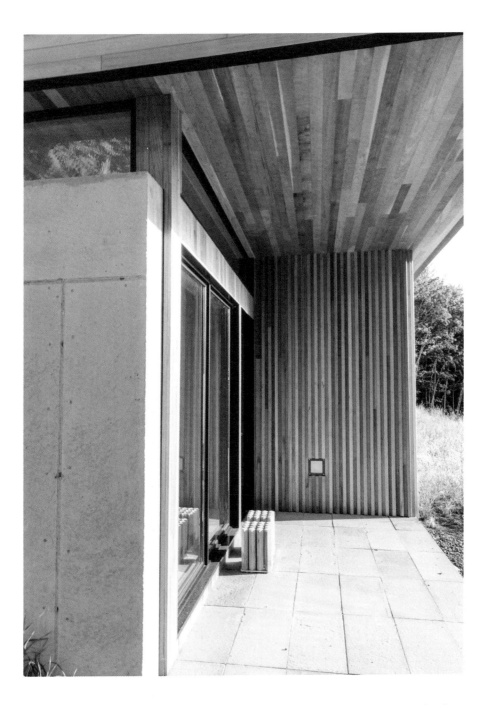

Timber walls and roof eaves flip the traditional beach house deck upside-down in a clever contemporary take.

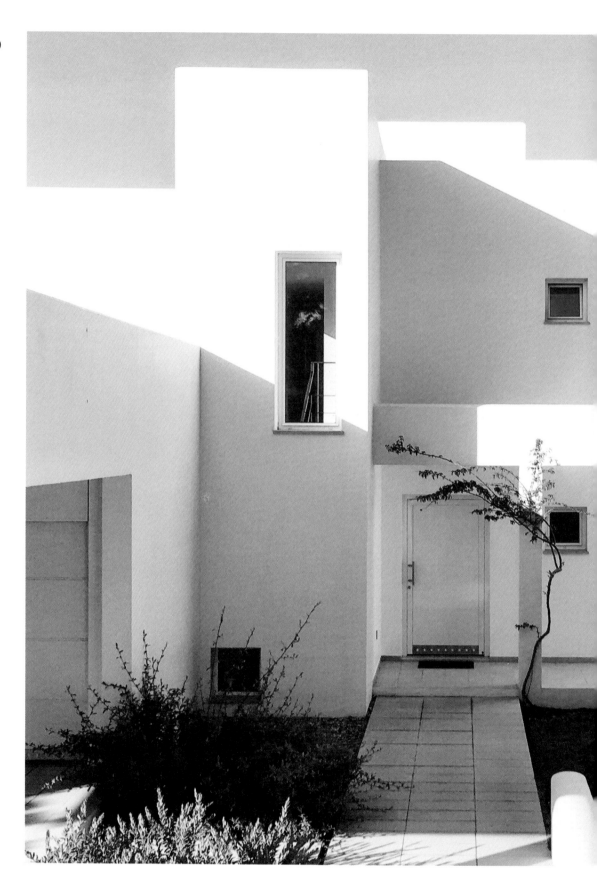

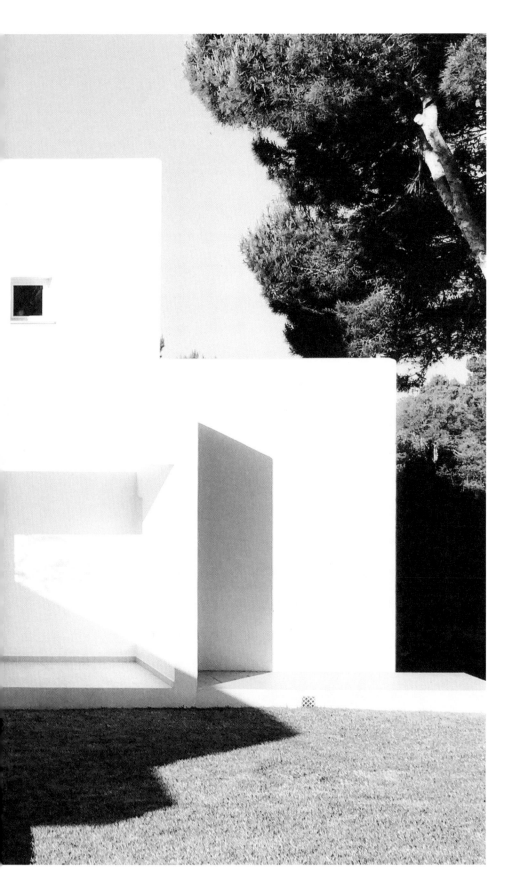

Whitewashed walls and an angular, flat roof take their cues from the Greek Islands, but with a modern beach house twist.

Harper *by* Design
An imprint of HarperCollins*Publishers*

HarperCollins*Publishers*
Australia • Brazil • Canada • France • Germany • Holland • India
Italy • Japan • Mexico • New Zealand • Poland • Spain • Sweden
Switzerland • United Kingdom • United States of America

HarperCollins acknowledges the Traditional Custodians of the land upon which we live and work,
and pays respect to Elders past and present.

First published in Australia in 2023
by HarperCollins*Publishers* Australia Pty Limited
Gadigal Country
Level 13, 201 Elizabeth Street, Sydney NSW 2000
ABN 36 009 913 517
harpercollins.com.au

A catalogue record for this book is available from the National Library of Australia.

ISBN 978 1 4607 6448 0

Publisher: Mark Campbell
Publishing Director: Brigitta Doyle
Editor: Jess Cox
Writer: Jo Stewart
Designer: Mietta Yans, HarperCollins Design Studio
Front cover image by Andy Abelein / Unsplash
Back cover image by onurdongel / iStock
Photographs courtesy of Unsplash, iStock and Shutterstock
Colour reproduction by Splitting Image Colour Studio, Clayton VIC
Printed and bound in China by 1010 Printing

8 7 6 5 4 3 2 1 23 24 25 26